A PHOTOGRAPHER OF NOTE

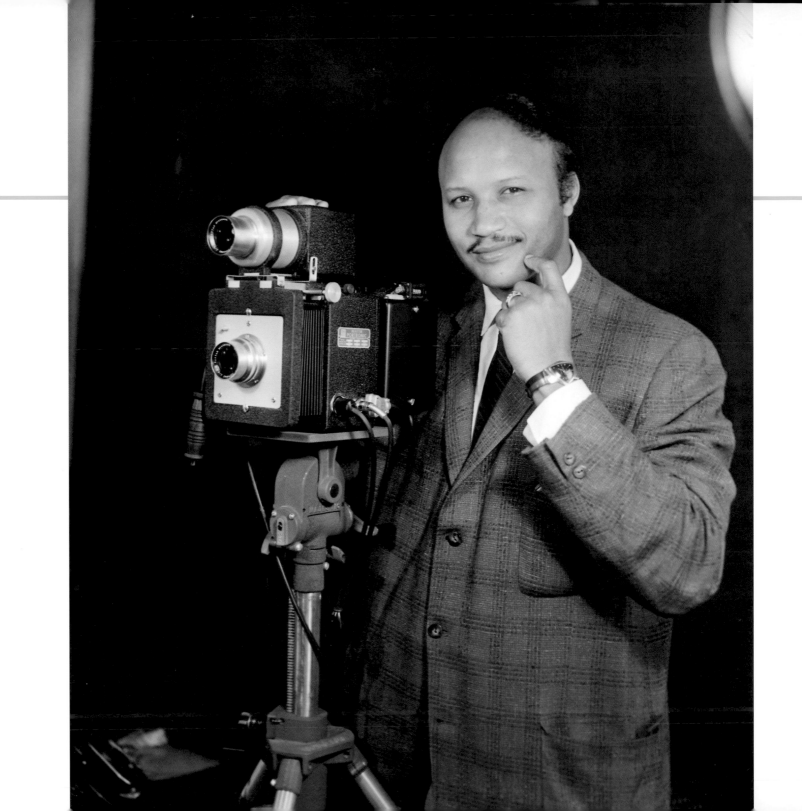

A PHOTOGRAPHER OF NOTE

ARKANSAS ARTIST
GELEVE GRICE

ROBERT COCHRAN

The University of Arkansas Press
Fayetteville
2003

07 06 05 04 03 5 4 3 2 1

Designed by Liz Lester

⊗ The paper used in this publication meets the minimum requirements of the American National Standard for Permanence of Paper for Printed Library Materials Z39.48-1984.

LIBRARY OF CONGRESS CATALOGING-IN-PUBLICATION DATA

Cochran, Robert, 1943–
 A photographer of note : Arkansas artist Geleve Grice / Robert Cochran.
 p. cm.
 Includes bibliographical references and index.
 ISBN 1-55728-736-8 (cloth : alk. paper)
 1. Grice, Geleve, 1922– 2. African American photographers—Arkansas—Biography.
3. Photographers--Arkansas—Biography. 4. Photography—Arkansas. I. Grice, Geleve,
1922– II. Title.

TR140.G735 C63 2003
770'.92—dc21 2002011190

CONTENTS

INTRODUCTION

I first encountered Geleve Grice's photographs at the end of 1998, as the beneficiary of a friend's thoughtfulness. Michael Dabrishus, Special Collections Librarian at the University of Arkansas, visiting Pine Bluff on business, was struck by a small exhibit of wonderful photographs in the Leedell Moorhead-Graham Gallery on the University of Arkansas at Pine Bluff campus. It was my good fortune that a part of his response was the thought that "Bob Cochran would really like these." Mike called the next day, and I've been grateful ever since.

A week later I was in Pine Bluff myself, visited the exhibit, and met the man who put it together—Henri Linton, chair of UAPB's art department. From there it was an easy step to telephone Geleve Grice himself and set up the first of many visits. From the beginning, I had a grand plan, to be executed in three stages, with the double purpose of bringing applause to Mr. Grice by bringing his work to the Arkansas citizens whose life it celebrated. Step one would be a public program in Fayetteville—Mr. Grice would preside, guiding his audience through a selection of his photographs projected as slides. For the second stage, I would prepare a short biographical sketch for the *Arkansas Historical Quarterly*. Finally, uniting the pictures with the life of the man who made them, there would be a lovely book for the University of Arkansas Press. From our first encounter, Mr. Grice presented himself to me as a man with deep Arkansas roots, and his photographs were in many instances conscious efforts to record and preserve the life of Arkansas people. It was most appropriate, then, that the state's major university, its leading historical journal, and its university press would take up the work started by Henri Linton and lead the way to Mr. Grice's long-overdue greater recognition.

From this point everything happened very much as planned. Mr. Grice came to Fayetteville on February 25, 1999, accompanied by his son Michael, for a presentation entitled "Treasure Untold: The Works of Arkansas Photographer Geleve Grice." The Fulbright College of Arts and Sciences came up with a nice honorarium, and the university rolled out the Razorback carpet, providing complimentary tickets for a great Hog basketball victory over number-two-ranked Auburn. At the pre-game party Mr. Grice, always on the lookout for good photo opportunities, took time out from his role as guest to line up shots of Athletic Director Frank Broyles, Chancellor John White, Senator Dale Bumpers, and other luminaries. *Northwest Arkansas Times* writer Maylon Rice ran a big story with great photos of Joe Louis and Louis Armstrong, among others, and wrote a wonderful column about how impressive Mr. Grice had seemed to him a quarter century earlier when Rice was getting his start as a cub reporter on the *Pine Bluff Commercial* in the early 1970s.

The presentation itself, the featured event on Fulbright College's list of programs in celebration of Black History Month, was a great hit. A big crowd showed up and was treated to a selection of approximately seventy-five of Mr. Grice's best photos, with instructive and entertaining commentary provided by the artist himself. At dinner afterwards my friend and English department colleague Professor Yemisi Jimoh, who had attended the evening's presentation, mentioned that she'd found Mr. Grice's close-up portrait shot of two unsmiling women especially moving. When I asked Mr. Grice if I could print her a copy from the slide, he was quick to give his permission—just as he had for the great spread printed by Maylon Rice in the *Northwest Arkansas Times*. It was too early in our friendship for me to understand it fully then, but it turned out that such gestures were more than simple generosity—were a key, in fact, to Mr. Grice's fundamental understanding of his vocation as a photographer.

Next, in the winter 1999 issue of the *Arkansas Historical Quarterly,* editor Patrick Williams ran "Geleve Grice: Arkansas Photographer," a brief biographical sketch accompanied by a selection of twenty photographs. Williams and I surprised Mr. Grice by running a photo from his navy days on the cover, the handsome young sailor relaxing in a Chicago nightclub with his very pretty date. For that we didn't even ask his permission, but he didn't complain. Then came a first unexpected happy accident—Bob Lancaster adapted the *Arkansas Historical Quarterly* piece for a

fine story in the February 18, 2000, issue of Little Rock's *Arkansas Times,* sending a staff photographer down to Pine Bluff for a cover shot of Mr. Grice, and running fifteen additional photographs to accompany it. So that was a double-barreled second stage—two articles instead of one, thirty-five photographs instead of twenty. There was even a nice little check.

This collection, then, is the third stage, planned from the beginning, of the collaboration of Mr. Grice and myself. We've worked hard putting it together. I traveled to Pine Bluff on at least ten different occasions over a four-year period, and visited the tiny hamlet of Tamo, where Mr. Grice was born, three times in his company and once by myself. I interviewed Henri Linton four times (artist, collector, unofficial historian of UAPB, he's a great figure in his own right) and Mr. Grice more times than I counted. I've got maybe ten hours of tapes. At this stage, too, we benefited from an unplanned bit of good fortune. Bill Gatewood, director of the Old State House Museum in Little Rock, offered space for an exhibit featuring Mr. Grice's work. Curators Gail Moore and Jo Ellen Maack worked with Mr. Grice and me to get it assembled in time for this book's appearance.

It should be stressed, however, that the photographs printed here, exhibited at the Old State House, and printed in the two shorter articles are but a tiny selection from Mr. Grice's total collection. Not even he has a good estimate of how many negatives, slides, and prints he stored in his Pine Bluff home and in two storage sheds out behind it. I probably looked at two thousand, choosing just seventy-five or so images for Mr. Grice's first Fayetteville presentation. Mr. Grice's entire photographic archive has yet to be cataloged—as this book goes to the printers it's in some eighteen boxes in the Special Collections Division of the University of Arkansas Mullins Library in Fayetteville. I've looked through them all, tens of thousands in all, spending whole weeks of evenings doing little else. Attempting a rough guess at the collection's overall size, Michael Dabrishus and I agreed that sixty thousand total images was a conservative estimate; there could be as many as one hundred thousand.

This selection includes many shots of famous people, of course, but I would confess right at the beginning that famous folks were not my primary interest. My initial recognition was that Mr. Grice's photographs were a treasure first and foremost because they recorded in great depth and

detail the life of a specific community at a specific time. More than half the photographs in Mr. Grice's archive were made in Pine Bluff, Arkansas, and close to half of these chronicle one or another aspect of life at the University of Arkansas at Pine Bluff. Surely one day a thorough pictorial history of that institution will be drawn from his work. Many of his photographs are either formal portraits (especially graduation pictures) or informal shots of people at work and play. Nearly all of these feature African Americans. It was this focus, geographic and cultural, that captured my first allegiance, and if any aspect of this collection privileges my preferences even over those of Mr. Grice, it would come in this area. Mr. Grice, while understanding and in most cases sharing my own emphases, would have likely included *every* image of Martin Luther King Jr., Joe Louis, Muhammad Ali, and other stars, had he made the selection himself (though he actually asked that the number of T-Bone Walker shots I selected be reduced). And in fact most of the images of these figures are included. But as it happened we worked the other way—we sat in his house, hour upon hour, looking at negatives and prints. I would find shots I couldn't imagine leaving out, and he would give me his best recollection as to when and where they were made, identify when he could the people included, describe the impulses that led him to stop and aim his camera. That's also how we did the captions. This selection, then, though it has Mr. Grice's approval, is mine, made in admiration, with a scholar's and regional historian's ends in mind. It should also be noted that the focus on black and white photographs results in an emphasis on Mr. Grice's earlier work—sometime in the late 1960s or early 1970s, he started shooting mostly in color when the big Speed Graphics he'd been using since his navy days gave way to lighter and smaller Leicas and Nikons. The images included here would never suggest it, but my own guess would be that by now color negatives greatly outnumber black and whites in Mr. Grice's collection.

I have made an effort, taking advantage of the great wealth of very recent studies, to locate Mr. Grice and his work in the larger traditions of African American photography. A more qualified photographic historian would have been an ideal collaborator for Mr. Grice—almost everything I know about African American photographers I learned after meeting him, as a part of my effort to more adequately comprehend his accomplishment. But no such expert being immediately at hand, I felt justified in letting my own interest lead me on. I happily affirm, too, that such

"amateur" pleasures have always been an ancillary benefit of my projects. In 1988, when I first began studying the music of the Gilbert family in northwest Arkansas, I knew little of traditional music or its scholarship. All I had was my interest in, and admiration for, Phydella Hogan and her family. Ten years, two books, several articles, and hundreds of learning adventures later I was still no expert, but I knew more than a little and I'd had a lot of fun. Here, a similar interest and admiration is directed to Mr. Grice and his work. Always starting over has its peculiar appeal—if it's true that you never stick with any topic long enough to attain true mastery, you also live most of your days on the steepest slopes of the learning curve.

In this instance it has been a great joy to study the work of Ernest C. Withers, James VanDerZee, and Mike Disfarmer; to find Deborah Willis's magisterial *Reflections in Black* in a Smithsonian gift shop in Washington, D.C., and use its bibliography as the starting point of my researches; to range further afield and encounter the work of Roman Vishniac and Michael Lesy's *Wisconsin Death Trip.* The fruits of all these researches are sprinkled throughout the commentary. The extensive comments of Mr. Grice himself were gathered in taped interviews conducted between 1999 and 2001. They were reviewed by him as they appeared in drafts of this essay, so that at last his role in creating the text is very nearly as prominent as it is in the selection of the images.

Thanks are due to everyone mentioned in this introduction, as well as to Larry Malley, John Coghlan, Laura Helper, Brian King, Liz Lester, Archie Schaffer, and Maria Stafford at the University of Arkansas Press for turning a pile of pictures and a typewritten manuscript into a beautiful book. In the early stages my work was greatly assisted by Gary Underwood at the University of Arkansas and later by the photographic staff at Collier Drug Store in Fayetteville, who made hundreds of prints from negatives and slides and occasionally shot new negatives from old prints stuck to scrapbook pages. Bart Blackwell's fine work in framing prints for various exhibitions was also a great help. I'm also grateful to my student Khristan Doyle, whose careful searches through *Arkansas State Press* microfilm were a substantial help. Kimberly Young, as part of her George Washington Carver internship at the University of Arkansas in the summer of 2002, initiated the enormous task of classifying and cataloging Mr. Grice's archive. Thanks, too, to Chuck Adams, Rhonda Adams, Carolyn Allen, Bob Brinkmeyer, Debra Cohen, Mrs. Erma Glasco Davis, Mrs. Jean Grice

INTRODUCTION

Davis, Michael Grice, Andrew Kilgore, Susan Marren, Gordon Morgan, Adolph Reed, Carl Riley, and Lonnie Williams. My friend Henry Glassie pointed me toward *Pictures Tell the Story*, a lovely collection of the work of Memphis photographer Ernest C. Withers that aided me enormously in my approach to Mr. Grice. Sigrid Laubert, Ashley Piediscalzi, and Susana O'Daniel, office manager, editorial assistant, and student assistant at Fulbright College's Center for Arkansas and Regional Studies, handled many arrangements for Mr. Grice's visits to Fayetteville and mine to Pine Bluff with unfailing efficiency and good will. I especially thank Fulbright College of Arts and Sciences Interim Dean Don Bobbitt, Provost Bob Smith, and Chancellor John A. White for timely support—their help made the completion of this work possible.

Like all my other work, this project was made much more enjoyable by the participation of my family. Suzanne McCray, as always, was both editor and hostess, assisting in the choice between one image and another, welcoming Mr. Grice to our home, and tolerating night after night with massive piles of negatives and prints strewn about the dining-room table. Our sons Jesse and Taylor accompanied me on visits to Mr. Grice in Pine Bluff, and our daughter Masie dined with us after Mr. Grice's Fayetteville presentation.

This collection is dedicated to the memory of Diane Blair. This is appropriate on several grounds. In the first place, it brings together two of the passions Diane and her husband Jim shared—the fine arts and the state of Arkansas. Jim and Diane were of course in attendance when Mr. Grice showed his slides in Fayetteville, and both made it clear they were there in celebration of Mr. Grice's work and in support of my own collaboration with him. I appreciated that then, and I appreciate it now. When I learned of Diane's illness, the best thing I could think to do was print up and frame another copy of the same photo Yemisi Jimoh loved. Three or four days after I took it to her I received a beautiful note saying that the unflinching gazes of those two women were inspirational to her. "They've seen it all," she wrote, "and they're not blinking. There's so much enduring strength in that picture. I gaze back, and I feel some of that strength. It's just what I need—it's a wonderful photograph."

I agree. I hope this collection will make it abundantly clear both that Mr. Grice is in fact a "notable" photographer and that his life's work has been accomplished out of a durable wish to

serve his neighbors. For every photograph made to the order of a paying customer, there must be eight or ten made in response to a personal mix of aesthetic and documentary impulses. I found my title in the *Arkansas State Press*'s account of Mr. Grice's 1949 wedding, which closes with a description of the groom: "Mr. Grice, a senior and majoring in psychology, is a member of Alpha Phi Alpha fraternity, a member of the Arkansas Lions and a photographer of note." A prescient last word, given the work of the next half century.

If you visit Mr. Grice, or travel with him, you soon learn to anticipate the arrival, ten days or two weeks after your encounter, of a packet of photographs—your party at lunch, you with your children, Diane Blair chatting with Dale Bumpers, Mike Dabrishus at the Razorback basketball game, you at the wheel of your vehicle. Any accompanying note (often there is none) will be a terse one-liner—"Thought you might enjoy these"—but the message is nevertheless clear: "What we just did, the places we saw and the people we visited, is important, worth preserving. And that's MY job."

There is courtesy at the heart of this gesture, certainly, but also a professional's pride, the quietly insistent claim of a man with a lifelong mission. This collection, then, attempts to document the ongoing accomplishment of that mission, the sense in which Mr. Grice sent that same message, again and again, to the people of his community. The fabric of your lives, he says, of our shared lives, is excellent and lovely. It deserves commemoration, calls out for artistic celebration. I am, by my choice and by my many years of labor, your chronicler, teller of your tale, your photographer.

BEGINNINGS:

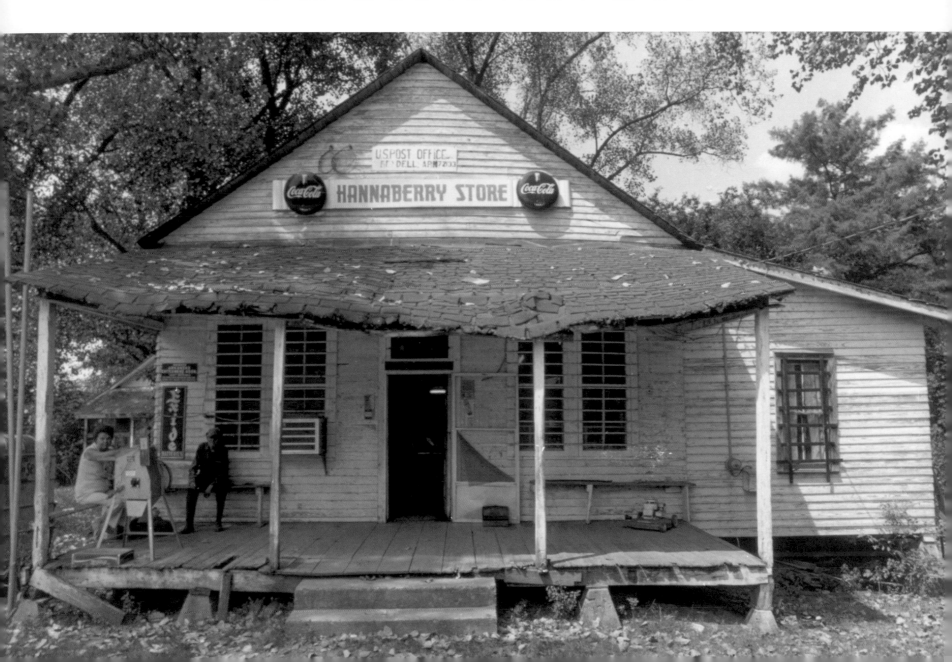

A LOCAL WORLD

The world that is home to Geleve Grice is a modest slice of Arkansas flatlands running south-east along the Arkansas River from Little Rock through Pine Bluff to the tiny community of Tamo, in the southeastern corner of Jefferson County. In a straight line the distance would total maybe sixty miles. Like thousands of other men of his time, Grice traveled widely as a World War II serviceman—between 1942 and 1946 he spent time in Chicago, New York, San Francisco, and various Pacific islands. But for seventy-five of his eighty years he's been a deeply rooted man, living by deliberate adult choice in landscapes familiar from his childhood and youth.

This contiguous Arkansas scene has three focal places: Tamo, where Grice was born in 1922; Little Rock, where he graduated from high school in 1942; and Pine Bluff, center of centers, where he's lived and worked since 1946. This Arkansas is a small, compact world, but it has its diversities. Within its borders, Tamo is a deeply rural farming community, a place of fields and woods. Little Rock is by comparison strikingly urban, the state's capital city, the closest thing Arkansas has to a major metropolitan center. Pine Bluff is in between, geographically and culturally, Jefferson County's seat and largest town.

Beneath these differences, in the years of Grice's childhood and youth, was a common social denominator—country life, city life, and town life were all rigidly segregated. In all three places, Grice grew up in an African American world. White folks may have been running the show, but they were far away, for the most part distant if vaguely dangerous figures. As a child in the country and a youth in the city Grice rarely encountered them. From grade school in Tamo through Dunbar High School in Little Rock to a college diploma from Arkansas Agricultural, Mechanical and Normal College (AM&N) in Pine Bluff, he never had a white classmate or teacher. His high-school and college football teammates and coaches (and opponents) were all black. In short, he

was raised in Arkansas's African American communities, and even today they have his deepest loyalties. As late as the summer of 2001, he was making trips to Little Rock to photograph homes of the community's leaders—L. C. and Daisy Bates, Dr. John Ish, Dr. J. R. Robinson—in support of efforts dedicated to their preservation and restoration.

But the beginnings, eighty years ago, were in Tamo, out in the country. Geleve Grice's earliest memories are of farming routines, of hundreds of mules being harnessed for work in early morning light, of learning to hunt and fish with his father and uncles, of pie suppers and "toe-touching parties" in the local church. His recollections are for the most part warm ones, focused on family and community life:

> My grandfather and grandmother, my father's parents, lived down at Phoenix. Charlie Grice was my grandfather and Nora Grice was my grandmother. My mother's maiden name was Hodge. She came from Clarksdale, Mississippi, but I don't know how my father met her. My father's name was Toy Grice. I was their oldest child. I was born at home. Midwife came, that's what they tell me. There were seven of us—five still living. My brother Toy is the fourth down the line. He's in Honolulu now, retired as an Air Force sergeant. He's fixed, got a palatial home over there. I've got a sister in Las Vegas, Verlia Grice Hogard—she's doing well too, works as some kind of county supervisor. She's the baby, the youngest. My sister Ruby lives in Seattle. She's a registered nurse. She's retired from Boeing, has a son who's a flight attendant for Delta Airlines. She's the youngest except for Verlia. My brother Charlie Grice got a Ph.D. in Education. He's retired, lives in south Florida, comes up here once or twice every year.
>
> My two oldest sisters are deceased. Ernestine—Ernestine Grice Givan—ran the reformatory for boys down at Wrightsville. She was a beautiful girl—Faubus loved her. She was there when those twenty-one boys got burned up down there. They had a disastrous fire down there—a terrible tragedy, doors were locked, no way they could get out. They buried them all in Havens Rest Cemetery in Little Rock—on West 12th Street.[1]

1. The fire at Wrightsville's Negro Industrial School for Boys occurred March 5, 1959. Twenty-one young men died. A letter in the *Arkansas State Press* protesting Faubus's plans to fire the superintendent, a man named L. R. Gaines, was signed by Ernestine Grice Givan. (*Arkansas State Press,* April 3, 1959, p. 2.)

She finally moved to Seattle—her husband was a skycap at the International Airport, made a lot of money. My oldest sister, also deceased, was named Georgene. She lived in Seattle, too, worked as a cashier in a bank. Married, had two kids, a son and a daughter.

They all went off and made good lives for themselves. I'm the sorriest one! I like hunting down here. I like the simplicity, the woods and the fields. I like the food, the friendliness of people down here. That's why I came back, why I stayed.

We had a church down there, called Richardson Chapel Baptist Church. It's not there anymore. During the school season it served as the school. They had it partitioned off—older kids up in the front section, lower grades back in the back. There was a big blackboard —each grade would have a turn, go up to the board and work problems. No plumbing— the privy was about fifty, sixty yards in the back, one on one side for the boys, one on the other for the girls. Called the privy—that was a horrible place!

My father was the principal and the teacher down there. He was a ruler; he ran everything. My mother, back in the hard times, she would make a big black pot full of soup, good soup, and send it to the school. My father was a leader, you might say.

Then they'd have social events there, too. Box suppers, toe-touching parties. That's right, that's what they called them back then. The girls would line up behind sheets, all the way across the room, and stick their toes out. The one you touched, that's the one you'd sit out there and eat out of the box supper with. If you get an ugly gal, hell, you still got to sit there and be nice, eat chicken, potato salad, sweet potato pie. That was for kids, maybe thirteen or round in there when you start.

I've been a hunter my whole life. When I was eleven years old I used to go out and kill squirrels, rabbits, and quail. We ate every one of 'em—all those people back in those days had single-barrel or double-barrel shotguns. Big hammers on the back. We hunted for fun, but we were hunting for food, too. You ate rabbit and squirrel back then or you didn't eat. And it was good. My mother could take that hind leg and split it, make two pieces out of it. Salt and pepper, put onions on it, rice and gravy. Made some good eating! I never ate possum or coon—some did, but our family never did. So I grew up hunting—that's why I like to hunt right now. I'd rather hunt than make love!

Except for the privy, this comes across as a rambling recollection of mostly good times. The young man's parents were pillars of their community—his father a teacher, a "leader," and his mother a skilled cook and homemaker. Even the listing of successes by his siblings, placed as it is in Grice's memories of his earliest years, serves to validate the people and places that launched such outstanding lives. Like any good childhood place, the ground of his birth is remembered by Geleve Grice in nearly Edenic terms, as a peaceable kingdom in a bountiful garden.

Only one photograph survives from this life at Tamo. Appropriately enough, it's a full-bore "baby picture." Grice, of course, is not the photographer. Too young for pants or overalls, he wears a kind of baby's shift. His face is full, even serene; his feet are bare. He's the center of the photo's attention, its only subject.

Like all such orders, however, the pastoral childhood sustained for Geleve Grice by his parents and community came to a sudden end. Times were hard, after all—the 1930s had succeeded the 1920s, and the whole country was gripped by the Great Depression. And the place was hard, too—this was the Deep South, home at that time to a deeply entrenched American apartheid. Sometime in 1935, the big world came to the little world of Tamo and tore it apart:

> We moved from Tamo in 1935. To Little Rock. My father and Uncle Willie Richardson got in trouble with a white rider named Price. He worked for a big farmer named Joe Gocher, or maybe Golcher. I couldn't say how it's spelled. He's known down here, had a great big place down by Grady, owned thousands of acres of land, hundreds and hundreds of mules. Price was his rider, like an overseer. Anyway, he and my father and uncle got into it—they beat him up a little bit. They brought 'em up to Pine Bluff and put them in the jail. Years later I did a picture of Price, at some reunion or graduation banquet down in Moscow. Great big red-nosed guy, 6'6" or so. He's dead now. I'm sure he didn't have any idea who I was—son of the man got put in jail and run out of the county for beating him up. My father left a big farm down there, but that's the story of how we got out. Back in those days it was kind of tough, you know. We wanted to get out of there because we didn't want any problems. We fled in disorder! My uncle left, too, with his wife and daughter, came up to Little Rock with us.

Little Rock, in 1935 a city of nearly eighty-five thousand people, was a definite comedown for Toy Grice and his family. In Tamo he was a schoolteacher, a community "leader"; in Little Rock he was just another poorly educated black man, and the only work he could find was menial. For his son there was a similar experience of loss—his education in the one-room Richardson Chapel church/school left him ill-prepared for what awaited him at Dunbar High School, a proud school with a distinguished faculty, easily the best then available to the state's African American students.

It's often forgotten in the glare of national attention focused on the integration struggles at Little Rock Central High School, but many African American citizens of Little Rock viewed the arrival of integrated schools as a decidedly mixed blessing, sensing early on that success itself would undermine what they had worked so diligently to establish at Dunbar. When Beth Roy interviewed Jerome Muldrew for *Bitters in the Honey,* her retrospective oral history of Little Rock Central's integration, his pride in Dunbar High was still apparent: ". . . I had a lot of pride in my school, which I thought, I thought it was just as good as Central. . . . And we had Ph.D.'s there, we had people with master's degrees teaching us."[2] Even now, at the beginning of a new century, with Dunbar's last high-school class graduated almost a half century ago in 1955, the school still maintains an active alumni association, with a membership of more than one thousand.

In the long run it's clear that the move "in disarray" from Tamo to Little Rock was a huge blessing to Geleve Grice and his siblings, despite the oldest's initial educational struggles. It was, for all its internal character, its beginnings in fear and dispossession, a classic immigration story— if Toy Grice descended several rungs on the social ladder, he nevertheless launched his children into a much larger world. The ladder in Little Rock, especially at Dunbar High School, went a whole lot higher. The young man recognized it, too; even in recollections sixty years later, his pride in the school's faculty and in his own achievements as a "pretty good student" is evident. In the 1970s and 1980s, he regularly attended (and photographed) Dunbar alumni reunions.

> When we came to Little Rock my father got a job working at the Marion Hotel,
> where the Excelsior is located now. I used to work down there too, as a waiter and in the

2. Beth Roy, *Bitters in the Honey* (Fayetteville: University of Arkansas Press, 1999), pp. 39, 40.

laundry. I was in high school then. You could make five or six dollars, maybe up to ten dollars a week. You have to remember you could put a pair of shoes in layaway for fifty cents back then, and pay it out. My father and I used to walk down to work. We lived at 22nd and Cross—the house is still there—and the Marion Hotel was at Markham and Main. We walked down there every morning—something like twenty-three blocks. The principal of the school at Dunbar lived right across the street from us—J. H. Lewis. My father was a deacon in the Archview Baptist Church—he was quite an affable man. He was real smart—passed away the same year Kennedy got killed. 1963. Had a heart attack.

When I went to Dunbar I was in the 7th grade. I had a terrible time—I was way behind. The teachers were all tough, mean as hell. You didn't make friends with teachers in high school in those days. You couldn't hardly even look at a teacher. But eventually I turned out to be a pretty good student. There was one English teacher who was good to me—Helen Curtis—and a math teacher I liked whose name was Eloise Bradford. She came from Talladega College, down in Alabama. She really looked like a white woman; her daddy was a brick mason in Little Rock. But she was tough as hell, too. Back in those days not too many teachers got master's degrees. But Dunbar had a strong faculty—most of the teachers had degrees from Morehouse or Howard or Tuskegee, places like that. All those were top schools for blacks in those days.

But if the schools in Little Rock were much more challenging than the classes taught by his father in Tamo, life in the city had its compensating attractions. One of these was sports—Geleve Grice became something of a star football player during his years at Dunbar, playing center on offense and what would today be called linebacker on defense. Football would be a big part of his life for a long time—after high school he would play on military teams, and still later for his college squad.

But another Little Rock discovery would turn out to be even more important. One day on a downtown city street, he noticed a photographer at work with a large-format Speed Graphic camera. A little later, playing football, he remembers lifting himself from the ground, muddied and bruised, and seeing another photographer, warm and dry, nattily dressed, in possession of impressive equipment. It was an epiphany of contrasts, and even now his recollections of pho-

tography's immediate appeal have as much to do with the profession's comforts and status as he then perceived them as they do with the technical aspects of the work:

> There are a lot of perquisites that go along with being a photographer. Everybody likes a photographer. During my time, when I was really in it, I carried press cards from the Arkansas State Police. You show that you can go anywhere. You go up front—you don't have to go to the back. You're just kind of admired by the public. You get free steaks, free booze, walk right in. It's kind of prestigious. That was how it seemed to me back when I first noticed those photographers in Little Rock, and that's pretty much how it turned out.

> I played football for three or four years, did pretty well. I played center, made All-State my senior year. The coaches were teachers—I remember one of them taught industrial arts. Owen Jackson was his name. Another coach was Mr. Cooper. He taught carpentry. We practiced and played at Kavanaugh Field. That's where I saw the photographers I told you about. They looked good. It intrigued me. When I got a camera I started taking pictures of my family. Took pictures of girlfriends too—they liked that. I'm sure I had my own camera by 1940.

> There were two good camera stores in Little Rock back then—Jungkind's, at 10th and Main, and the Camera Center, at Markham and Main. A man named Joe Navarro was the top employee at the Camera Center—he helped me a lot, taught me about different cameras. I started hanging out at the office of the *State Press* while I was still at Dunbar. L. C. Bates, he set the type down in the basement. I always had a lot of initiative to learn about things I was interested in.

Actually, Grice did a lot more than "hang out" at the *Arkansas State Press* offices. One photograph in particular, preserved in the same scrapbook that features football pictures, shots of family and girlfriends, and photos of "Dear Old Dunbar," suggests at least a tentative foray into a larger world. It's a snapshot portrait of bandleader Andy Kirk, taken, according to Grice's recollection, in 1941 or 1942 in the *Arkansas State Press* offices, and it may be the first evidence of a growing confidence and ambition that one year later will have him arranging photographs of Joe Louis and Louis Armstrong in Chicago and Milwaukee.

But the big step of 1942 was not a photographic but a journalistic venture. During Grice's senior year, ten installments of a column of Dunbar gossip entitled "Campus Camera: 'Sees— Talks'" ran in the paper from February 27 through May 8. All were bylined, and only two were not accompanied by a small photo of a very young Geleve Grice. It was his debut as a published journalist—he was primarily a writer, not a photographer (only three installments carried photographs of various Dunbar students), but his name was in print; he understood even his words to be a kind of camera, and he understood as well that his "camera" could "talk," could record the lives of his fellow students. "Daisy Bates concocted that column—it was her idea. I enjoyed it—the kids liked to read about themselves. It made you a popular man on campus. I think she even paid me a little money for it."

All in all, it sounds like the youngster who came up from the country at thirteen managed the transition to city life with considerable success. Playing football, writing his high-school gossip column for the *Arkansas State Press,* taking his first pictures and getting some of them printed in the newspaper, and managing at the same time to "be a pretty good student," Geleve Grice was very much a young man on the go. But the move from Tamo to Little Rock was nothing compared to the move waiting for him after graduation. The year was 1942, the nation was at war in Europe and the Pacific, and Uncle Sam had plans for Dunbar High School's best and brightest.

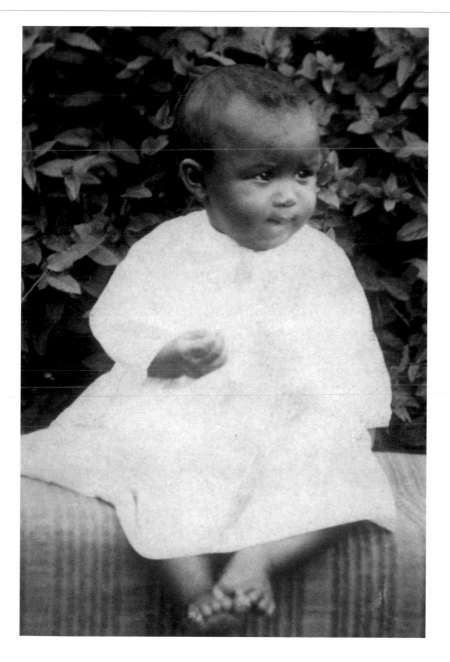

Geleve Grice, Tamo, Arkansas,
1922. Photographer unknown.

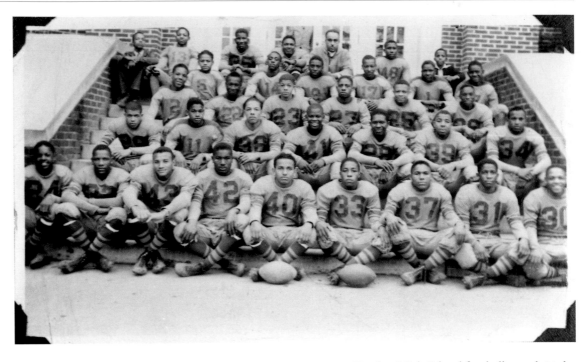

Dunbar High School football squad, Little Rock, 1942. Geleve Grice *third from left, first row*. Photographer unknown.

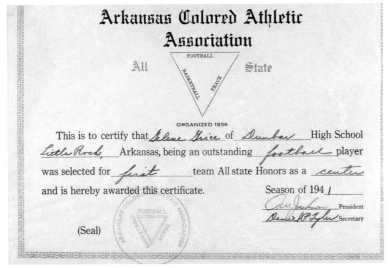

All-State football team
certificate, 1942.
Photographed for this book.

High-school beauties, Little Rock, 1942.

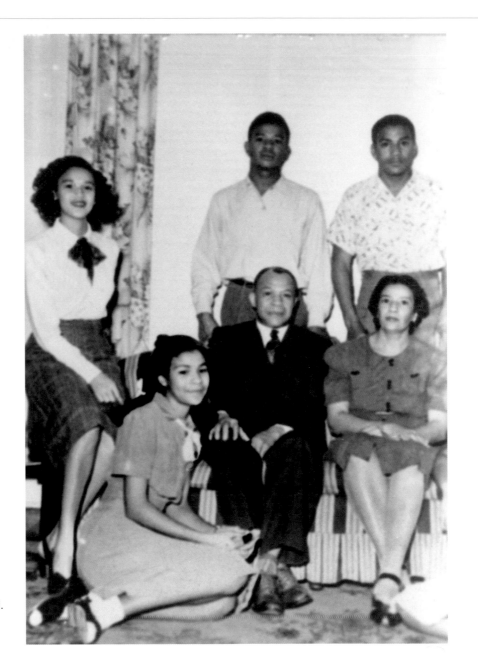

Family portrait, Little Rock, 1945.

Andy Kirk, Little Rock, 1942.

Proud mother, Little Rock, 1945.

THE BIG WORLD:

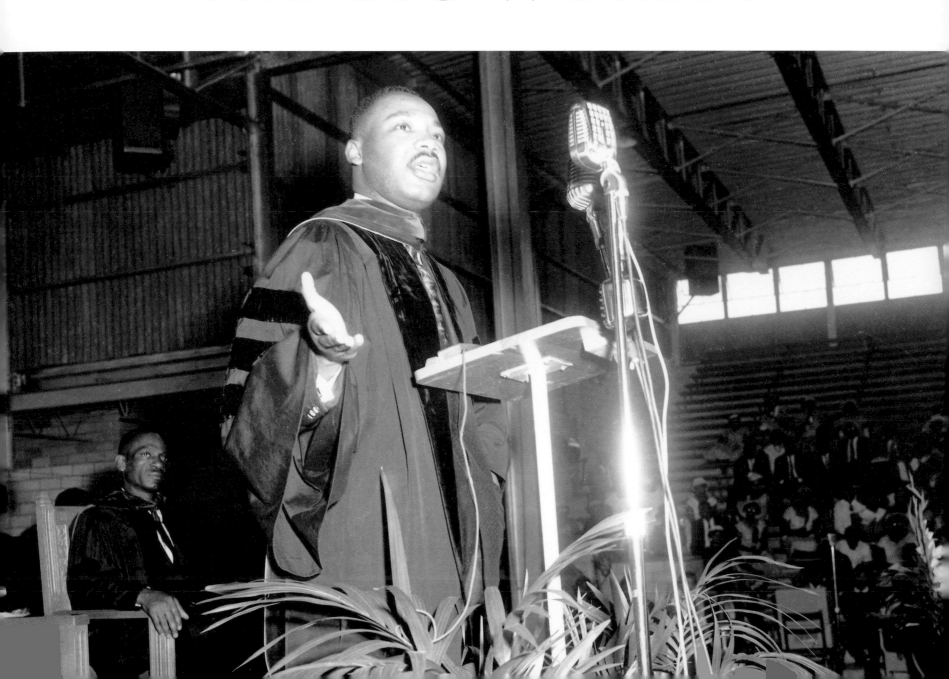

1942-1946

In fact, his future in faraway places had already been contemplated at the local level. His high-school principal was ideally placed to manage the transition of his charges from cap and gown to uniform —he doubled as a navy recruiter. No doubt his motives were sincere; the American armed forces were rigorously segregated at the time, and a belief that the navy offered greater opportunities for African Americans than the other branches was widespread. And so it happened that the newly minted high-school graduate soon found himself in Chicago, courtesy of the U.S. Navy.

> When I graduated I volunteered for the navy. The principal of Dunbar after Mr. Lewis passed away was Dr. Christopher, and he was a navy recruiter. He encouraged me to go into the navy. The army, it was really rough back then. And you had to volunteer pretty quick or you'd be drafted for sure, and if you got drafted you were in the army, might get sent anywhere.

The navy sent Grice to Illinois, to Great Lakes Naval Air Station. On his leaves in Chicago, he would accomplish a series of amazing photographs. Armed now with a better camera than anything he'd owned in Little Rock, he captured many of the day's most celebrated figures at work and play. A uniformed Joe Louis smiles with a bevy of chorus girls; Eleanor Roosevelt stands at the foot of stairs, surrounded by a group of uniformed women; a beaming Louis Armstrong sits, horn in hand, at a table with patrons; electric guitar pioneer T-Bone Walker wows a crowd by playing his instrument behind his head.

> I almost always had my camera with me. I never had much trouble getting people to pose for pictures. I was a young guy, wore my uniform most of the time—I think most of the time I was thought as more of a fan with a camera than a professional photographer who would be trying to sell the pictures. I never had any trouble with the club

owners—I wasn't loud or aggressive, pushing my way into things. Most people, you know, they like to have their picture taken, not just with celebrities either. Like I told you, that was one of the reasons I was attracted to photography in the first place—I don't care where it is, nightclub or a wedding or a football game, you're a photographer you always get a nice welcome, get treated real well.

Surely it was a frightening time—he was training for war after all—but it was an exhilarating time too, a young man's first taste of the world's attractions.

They sent me to Great Lakes, in Illinois, for six weeks of basic training. I was at Camp Robert Smalls—that was all blacks. The navy wasn't as rough as the army, but everything was totally segregated in those days. They'd take us out on Lake Michigan, make us row the boats, swim, jump off platforms in ten or twelve feet of water. There was one big guy I knew from Mississippi. He couldn't swim. Big guy. He jumps, next thing we see is his big feet sticking up. They had to jump in and get him. Another funny thing was every time you come back from leave they asked if you ever had VD—one guy said, "I've had a touch of it"!

After I finished basic training they sent me on to gunnery school—that was at Great Lakes too. There was a little period in there when I got to work in the base library for awhile. That was after basic training, maybe before I went to gunnery school. I liked that. I was there when Dorie Miller came through—he was a hero at Pearl Harbor, cook or a baker on a ship. He grabbed a .50-caliber machine gun, shot down some planes. He was a great big guy from Texas, 6'6" or so. The navy sent him around giving talks.

I played football while I was at Great Lakes too. They had a great team, some of the best players in the country. Paul Brown was the coach. He was mean as hell. I played center again, backed up the line on defense. In practice Brown sent four guys at you—three blocking and one carrying the ball. It was hard to make a tackle—impossible. That's how Brown coached. I was on the team that beat Notre Dame—Johnny Lujack was playing for them then. It was a huge game—lots of professional guys on that team. Jim Mello—he went to Notre Dame, but he was in the navy then and played for our team. I didn't play in that game.

We mostly went down to Chicago when we got leave, but sometimes we went up to Milwaukee if we had a little money. Joe Louis had an interest in this place in Chicago. He'd sit around there, quiet. He wouldn't say much. He was just a poor boy, kind of on the ignorant side. You had to probe to get anything out of him.

Those pictures of Eleanor Roosevelt—they were taken in Chicago. They had a big USO at 49th and Wabash, down on the South Side. She was in the vicinity—I went over out of curiosity. Had a Speed Graphic 2¼" by 3" format, not the bigger 4" by 5" negative, bought it at a pawnshop in Chicago. I think the women are part of some Masonic group—Eastern Star or something like that. I have vivid memories of her. She had kind of a whining voice. I didn't know too much about her then, but black people all liked her. There was a big controversy when they first had the airmen at Tuskegee, the first black men to serve as military pilots, so she went down there and went up with one of them in a trainer. They had two seats—the instructor stayed in the back and the pilot was up front. She did that sort of thing a lot. The segregationists, they really hated her.

On all these forays, Grice was still an amateur, strictly speaking, a twenty-one-year-old sailor on the town with his date and his camera. He was a soldier, not a photographer. But the photographs are anything but amateurish: time after time, amid the hectic bustle, less-than-ideal light of nightclub settings, and the hurry and nervousness that interfere when the subject posed before you is the nation's First Lady, he manages sharply focused and effectively composed shots. Opportunity had yet to knock, years of soldiering and schooling were ahead, but when the young man from Little Rock and Tamo, Arkansas, saw his prints, examined for himself the pictures he had made, surely he recognized at least something of what he had accomplished. They were good, even excellent. He was a photographer.

After I finished gunnery school at Great Lakes, I got sent out to New York for about a year before I was shipped overseas. I was at Floyd Bennett Field, in Brooklyn. It's still there, on Long Island. Bennett was a pioneer flier. When we left New York to go overseas I was a petty officer for the trip—I escorted troops. We went by train through Chicago to San Francisco—whole trip took five days and five nights. Stayed over there over a year in the Pacific. I was in the Marshall Islands—on Kwajalein, Eniwetok, Ebeye.

THE BIG
WORLD:

1942–1946

I was a boatswain's mate, second class. After gunnery school at Great Lakes, I had a right-arm grade. Not many black sailors had that. They mostly got left-arm grade, which was cooks and bakers. If you had a right-arm grade that meant you knew about the ship. Then when I got overseas they made me a brig master on Eniwetok. Got called MAA—master at arms. I guarded Japanese prisoners. That was the work I did—tough guys, that's what they said.

I took some pictures while I was overseas too, developed them myself in a little closet when I could buy the chemicals. Little tiny prints—it was the best I could do at the time. I still have some of them in a little scrapbook—shots of friends, our camp buildings, some of the Japanese prisoners. After I was stationed on Ebeye they put me on the cruiser *Baltimore* for a while. Then back to the islands. After that my time was up. I volunteered for three months longer. Then the war ended and I came home.

I enjoyed the navy. That may sound strange, but I did. I would have stayed in—you see, we didn't get good counseling back then. I had a good record—the years would have flown by. I could have stayed in and retired, like my brother Toy did in the air force. But then, too, I wanted to come out and finish college, which I did. But I was really pondering back then whether I should stay in or come out. That's why I volunteered for the extra three months. I finally got out in 1946—April 23, in Shoemaker, California—and headed straight back to New York.

The return to New York was undertaken with education in mind. Grice now recollects taking high-school level courses in Spanish and algebra while he searched for higher-education opportunities at Brooklyn College and NYU. He remembers that he stayed about six months, but what is recalled most vividly is the decision to leave.

Then one day I remember I went up in an elevator about fourteen stories, and when I got done with my classes there I came back down and hit the streets. And it just came over me that I couldn't handle the way life was up there. It was just so impersonal. I stayed in New York maybe eight months, trying to find my way. Then I gave all that stuff up, came on back down here and finished up at AM&N.

It had been a busy four years, filled with travel and adventures in love and war. He'd crossed the continent and the Pacific Ocean, guarded Japanese prisoners of war and photographed some of the day's most famous celebrities. Floyd Bennett Field, not to mention Kwajalein and Eniwetok, was a long way from Little Rock and Tamo. He'd been to Chicago's Rhumboogie Cafe, and he still has an ashtray, stolen from a date's apartment, from New York's famous Stork Club. The Stork Club itself he never visited—he now views even the dates with the woman who had been there as imprudent, an act of rash youth:

> Sherman Billingsley owned the Stork Club. I never went there. No sir, I sure did not.
> In New York City at that time—I don't think he was too cool on us. I got this ashtray from
> a girl's apartment up in Harlem—I was dating her, and I swiped it from her. I wouldn't do
> the things I did back in those days in New York for nothing, for love or for money!

The big world certainly had its lures, though some of Grice's stories—the all-black navy units, his fear of visiting the Stork Club—make it clear that the nation as a whole was very nearly as rigid in its segregationist racial codes as his Arkansas home. Even in the twenty-first century he could lament the lack of "good counseling" that might have led him to a career in the military. But the epiphany in the New York street proved pivotal. The big world, for all its excitement, was a place the young ex-serviceman found "impersonal." Formed by Tamo and Little Rock, he missed the rhythms of country and town life. Education was clearly on his mind—he'd spent most of his time in New York taking classes and checking out colleges—and the newly enacted GI Bill made a university education easily available. His sister was already attending Arkansas AM&N in Pine Bluff, his old mentors L. C. and Daisy Bates were going strong with the *Arkansas State Press* in Little Rock—for a twenty-two-year-old ex-soldier "trying to find my way," the lure of familiar ground was strong. He was ready to come home.

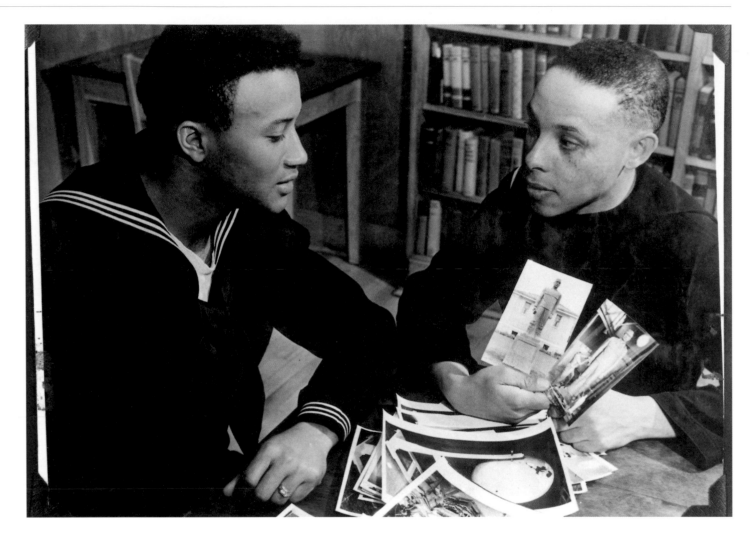

Two sailors, Chicago, 1943. Geleve Grice *at left*.
Photographer unknown.

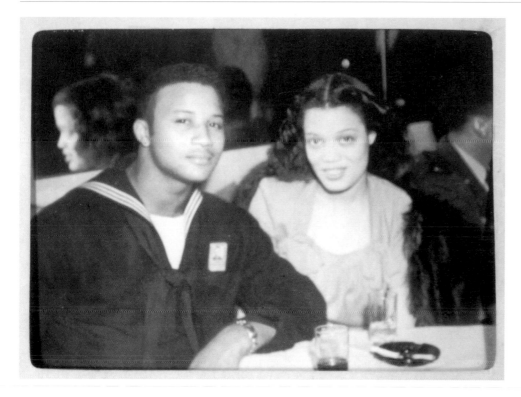

Night on the town, Chicago,
1943. Geleve Grice *at left*.

Rhumboogie Cafe Card, 1943.
Photographed for this book.

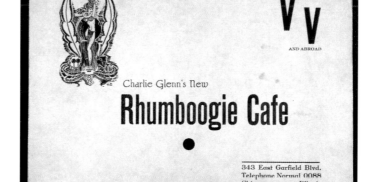

Louis Armstrong, Chicago, 1943.

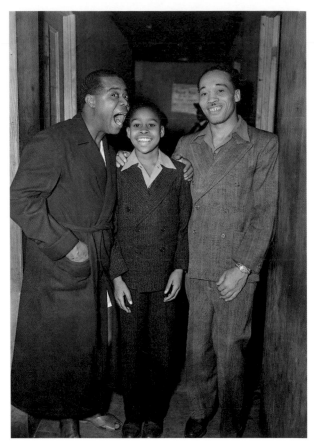

Louis Armstrong, Chicago, 1943.

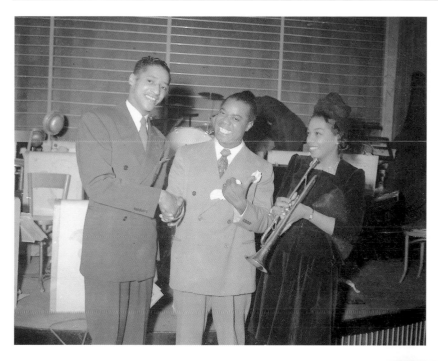

Louis Armstrong,
Chicago, 1943.

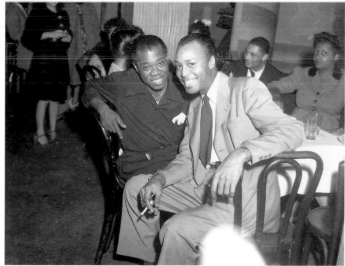

Louis Armstrong,
Chicago, 1943.

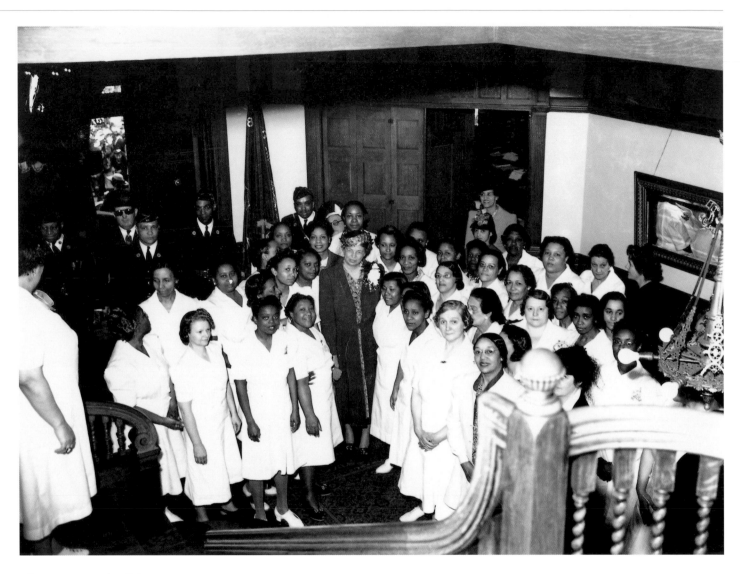

Eleanor Roosevelt, Chicago, 1943.

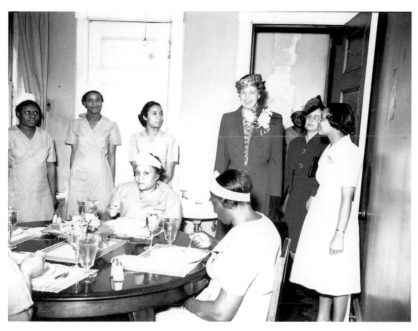

Eleanor Roosevelt,
Chicago, 1943.

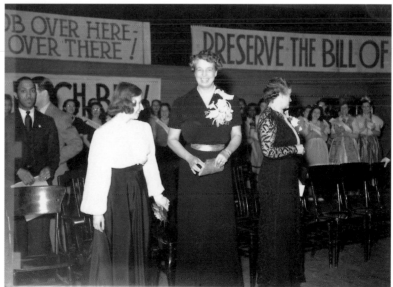

Eleanor Roosevelt,
Chicago, 1943.

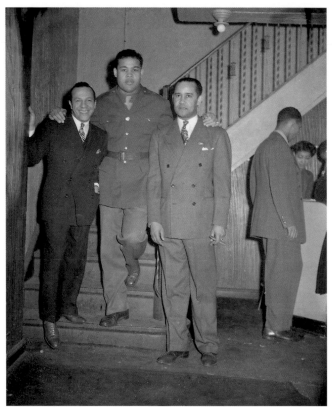

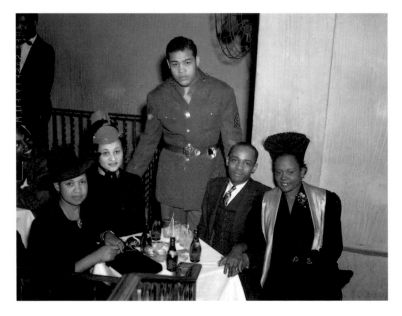

Joe Louis, Chicago, 1943.

26

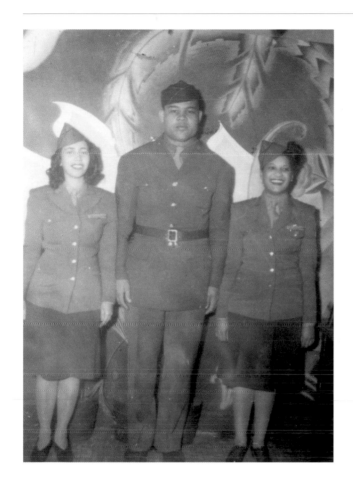

Joe Louis, Chicago, 1943.

Joe Louis, Chicago, 1943.

Joe Louis at diner, Chicago, 1943.

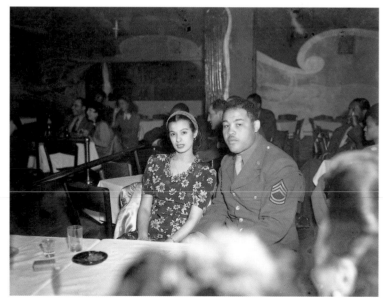

Joe Louis, Chicago, 1943.

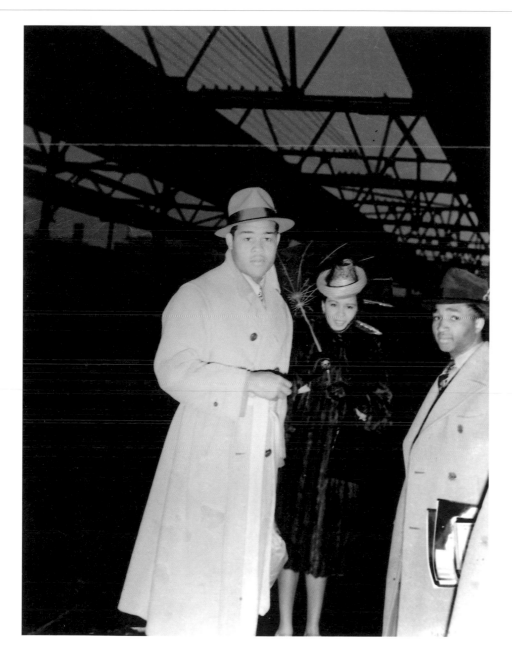

Joe Louis, Marva Louis,
Chicago, 1943.

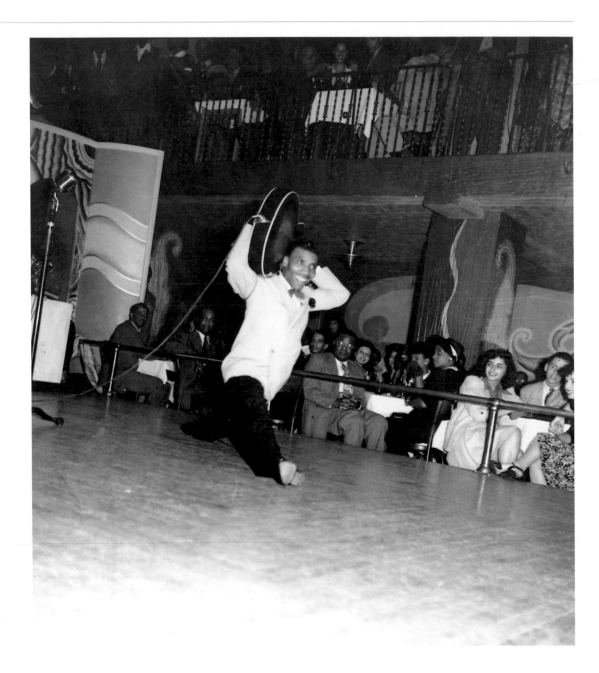

T-Bone Walker,
Chicago, 1943.

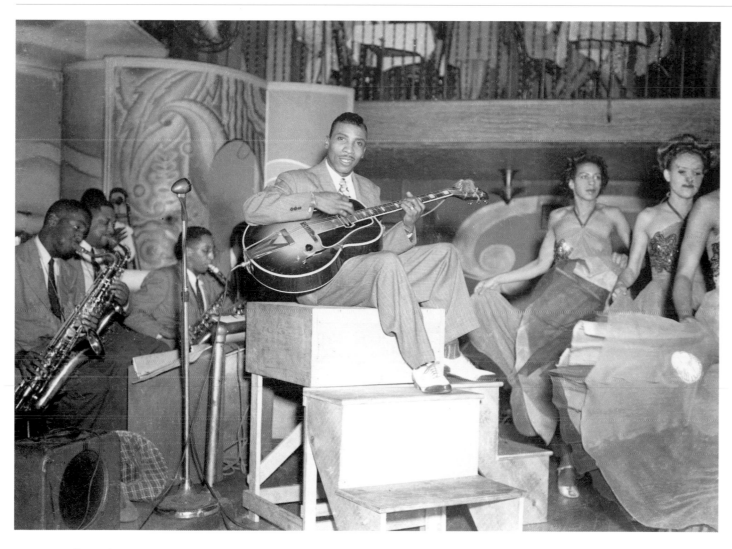

T-Bone Walker, Chicago, 1943.

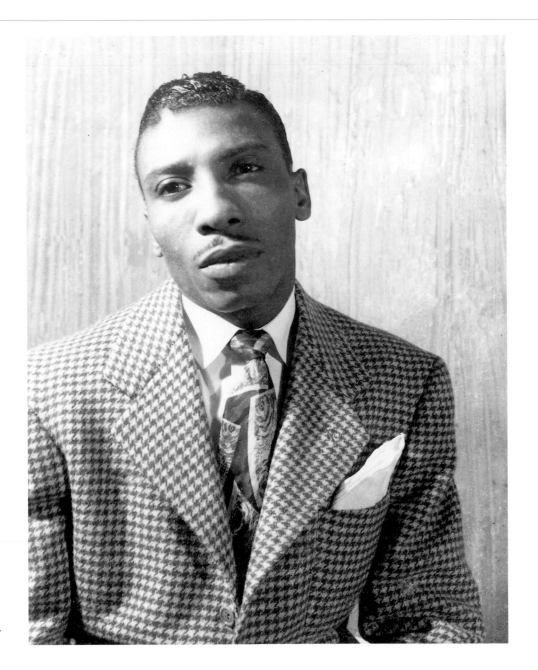

T-Bone Walker, Chicago, 1943.

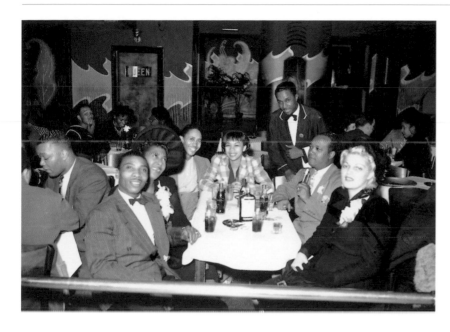

T-Bone Walker, Chicago, 1943.

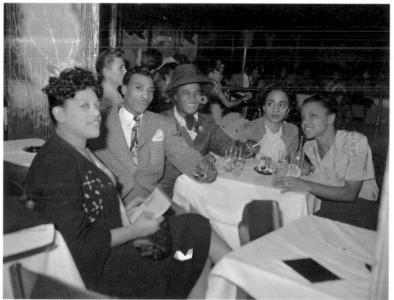

T-Bone Walker, Chicago, 1943.

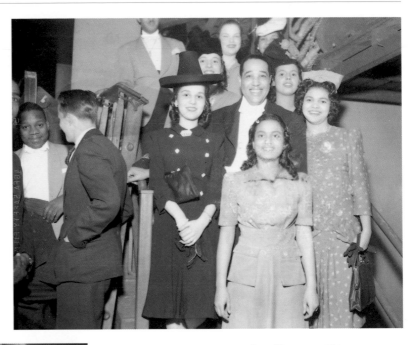

Duke Ellington, Chicago, 1943.

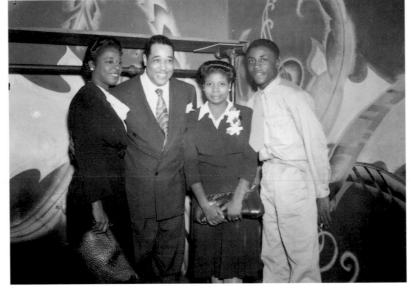

Duke Ellington, Chicago, 1943.

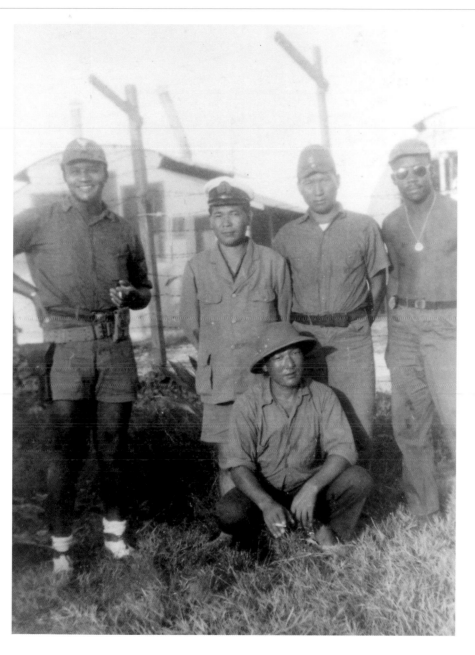

Three Japanese POWs,
Eniwetok. Geleve Grice *at left*.
Photographer unknown.

THE LIFE OF A PLACE:

1958-2000

Back home, Grice lost no time reestablishing himself. Taking advantage of the newly enacted GI Bill, he signed up for classes at AM&N in Pine Bluff. He majored in psychology, played football, and joined the Alpha Phi Alpha fraternity. More importantly, his work as yearbook photographer so impressed John M. Howard, chair of the art department and director of public relations for the college, that he hired him as campus photographer long before he graduated in 1950. For at least a decade after his return, he would find his primary employment with the college—the 1953 edition of the school yearbook, *The Lion,* lists him simply as "college Photographer," but by 1956 his title has improved to "Photographer—Special Photographical Consultant."[1] Nearly fifty years later Grice's huge photographic archive contains thousands upon thousands of images of AM&N life, everything from graduation and yearbook shots to football and basketball games and parades, classroom shots and faculty portraits, student dances and dedication ceremonies for new campus buildings. There must be more than one hundred shots of President Lawrence Davis.

Even today, Grice remains fiercely appreciative of the teacher who opened the door, made all this work possible.

John Howard was a great man in the college. He taught art, ran the art department, plus he handled all the publicity. You look in the *Arkansas State Press* you'll find stories almost every week. I took lots of pictures, and Howard wrote the stories. That's where I really started developing and printing more too—they had a little lab, just an enlarger and some chemicals, in a little prefab building. Once I opened up my own studio I did

1. Grice's formal employment as a staff photographer ended in 1960. For many years after this, he continued to photograph university events on a job-for-hire basis.

all my work myself—printing and enlarging. I taught myself, got some books and just
learned how to do it. It wasn't very complicated. All the black and white work I did for
myself. I got really sick of that darkroom. Once I started taking mostly color shots I quit
the developing and printing. Sent it all out after that.

Grice was not alone in anchoring his commercial photography in his home community via
an association with the local institution of higher learning—such prominent pioneer African
American photographers as Addison Scurlock in Washington, D.C., and Paul Poole in Atlanta
established themselves in much the same way. Serving as Howard University's official photogra-
pher, Scurlock (who with his wife and sons maintained a studio from 1911 until his death in 1964)
"documented community life: activities at Howard University, conventions and banquets, soror-
ity and social club events, dances, weddings, cotillions, and local business affairs."[2] Poole, begin-
ning in the 1920s, operated very similarly in Atlanta, billing himself as the "Official Photographer
of all Colored Colleges in Atlanta."[3]

In 1947, then, back from the war and his visits to the streets and clubs of New York and
Chicago, Geleve Grice found his future waiting for him on his home ground—in Pine Bluff and
Little Rock, and most especially at Arkansas AM&N. It was the right place at the right time, and
he was soon launched upon his life's work. In the beginning, his life was centered upon school,
upon Arkansas AM&N College. He loved it—even today he's a loyal alumnus, proud of the new
football stadium and the impressive accomplishments of the school's graduates.

Down here you had a great big campus, lots of room. Three years, I finished, because
I went twelve months a year on the GI Bill. My sister Ernestine finished out at AM&N
too, before I did. She was a cheerleader, good at dramatics. At first I played football at
AM&N too—they called me Great Lakes. I had a lot of fun. But then, at the beginning
of my senior year, I got married, young pretty wife, and that didn't fit too well with play-
ing football and staying in the athletic dorm. One day I saw a guy get his leg broke in a

2. Deborah Willis, *Reflections in Black: A History of Black Photographers, 1840 to the Present* (New York: W. W. Norton,
2000), p. 42.

3. Willis, *Reflections in Black,* p. 47.

game against Southern, bone sticking right out of his leg. Lee Allen Torrence—he still lives here in Pine Bluff. Got his doctorate, worked at AM&N in the president's office. That's when I figured it was time to give up football—got a yellow streak down my back.

Meanwhile, busy as he was down in Pine Bluff, Grice also moved very quickly to reestablish himself in Little Rock. His parents still lived there, and by the summer of 1947, the former high-school gossip columnist was appearing again in the *Arkansas State Press*. This time, except for one somber occasion in August, he was no columnist, but an "ace cameraman" whose bylined photos appeared regularly. Most often these are posed group portraits, sporting such captions as "House-Warming for Mrs. Bennett" (June 24, 1949), "Nuptials of Brilliant Couple Celebrated" (August 8, 1947), or "Methodism On Parade" (July 11, 1947). Soon enough, in September of 1949, the "ace cameraman" would find his own picture on the front page, second banana in "Miss Bell Has Evening Nuptials," a story announcing his marriage to Jean Bell. The event was accorded detailed coverage under a full-length photo of the smiling couple. The bride was from North Little Rock, a fellow AM&N student. They'd met on campus—she was best known as a fine singer. She went on to graduate, and later earned a master's degree from the University of Arkansas in Fayetteville (the Department of Music's first African American graduate student).

Amid all the busy industry, however—going to school in Pine Bluff, and doing his routine press photographs in Little Rock—the young veteran found himself on several occasions caught up in far more momentous events. One of these came in August 1947, when as the *Arkansas State Press* staff photographer he journeyed with Daisy Bates to the Tucker prison farm to witness a double execution. The *Arkansas Gazette* stories were brief—"Two Due To Be Executed at Sunrise" on August 8 (p. 6), and "Two Killers Executed at Tucker Farm" on August 9 (p. 3)—but the *Arkansas State Press* played it big, with two front-page stories leading the August 15 edition. Daisy Bates's "Social Neglect Ends in a Double Execution at Dawn" was the lead, but right beside it, running down the left-hand column with a photo of its author, was "I Saw Two Men Die," a "word picture by the PRESS ace cameraman Geleve Grice after being denied the use of his camera."

The article itself opens with a prefatory statement of idealistic purpose and worthy ambition: "Since my type of work afforded me the opportunity and I am dedicated to doing something

constructive for humanity and myself in my future efforts I consider it fitting for me to convey to you with words what it's like to witness two men executed." The "word picture" that follows is a somber, even eerie piece—"Everything was shrouded in an atmosphere of twilight and gloom when the guard opened the gate"—and half a century later, recollections of that morning can still unsettle its author. In the four years of our work together on this book, I heard the story at least seven or eight times, always (except for the first time) in the company of someone hearing it for the first time. "It made an indelible impression on me," he begins. "I have vivid memories of it right now." The execution itself was horrific, a barbaric spectacle, but Grice also still recalls how impressed he was by Daisy Bates:

> She was a tough person—walked right up to [Superintendent of Prisons Tom] Cogbill and [Assistant Superintendent Lee] Henslee. Cogbill's big old belly sticking out, like he was carrying triplets. And Henslee—he had no love for Negro people. He committed suicide later on. But Daisy didn't back off from anybody. She was always good to me, clear back to high school. I liked L. C., too, her husband. Used to sit in the back of the *Press* office with him while he set type. But I really admired Daisy.
>
> Why we went down there—it set a precedent. One of those men was a cabdriver, killed a white woman in Forrest City. Automatic death for him. But the other one killed a black man, an old night watchman down at the train station in Little Rock. Killed him with his own gun. That's why it was significant for us—first time a black man ever got executed for killing another black. It was progress, in a strange kind of way.

Six months later, in February 1948, while still a student at AM&N, Grice found himself involved in a much more welcome piece of progress. When AM&N graduate and U. S. Army veteran Silas Hunt applied successfully for admission to the University of Arkansas Law School in Fayetteville, he was accompanied on the journey to Fayetteville by NAACP attorney Harold Flowers, AM&N student Wiley Branton (who applied and was rejected for undergraduate admission to the College of Business Administration), and (as reported on the front page of the February 3, 1948 *Arkansas Gazette*) "Geleve Grice, photographer for the Negro *Arkansas State Press* of Little Rock and student at Arkansas A. M. and N. college."

It was a historic occasion. Hunt was the first African American since Reconstruction to enroll in a "white" southern university, and Geleve Grice was there to record the moment. Fifty years later, his shots are the most vivid record of the event.

 I knew Silas Hunt—we played football together at AM&N. I think he came from Texarkana. We were both veterans—he was in terrible battles, the Battle of the Bulge. He was seriously wounded. He graduated in 1948, two years ahead of me. He was junior class president in 1947.

 Hunt was a wonderful man—intelligent and dignified. He was in debate at AM&N. I just rode up with them and took the pictures—Harold Flowers wanted me there in case we got turned away. We all four went up in one car. Flowers drove—he had an old Frazier. I rode in the back with Hunt; Branton and Flowers were in the front. I remember the speedometer was broken—it jumped all around, said thirty miles per hour one minute and eighty miles per hour the next. Hunt kept looking at it, telling Flowers to slow down. Last thing we needed was getting stopped for speeding. The truth is we were scared to death—had no idea what we were getting into.

 But everything went very smoothly—they treated us fine. They told Hunt he'd be admitted, and turned Branton down. We had a little lunch and came on back—all except Hunt. He stayed behind—some people in the Fayetteville black community were helping him find housing. He wasn't really prepared to stay—didn't even have his clothes with him. Later on, when I was back in Pine Bluff, I got called in to see President Davis—turned out he'd gotten a call from the governor, Ben Laney. He was mad as hell, wanted to know what an AM&N student was doing up in Fayetteville taking pictures of this integration business. I told him Harold Flowers and Daisy Bates asked me to go. I guess President Davis took care of it; I never heard any more about it.

All in all, it was quite a start for the young veteran—not only going to school, playing football, and getting married, but also working both for the *Arkansas State Press* and for AM&N, witnessing executions and recording the integration of the state's leading university. By the time he graduated in 1950, Grice had already made a name for himself in Little Rock and in Pine Bluff. A photograph he titled "Varied emotions" of cheering AM&N students at a basketball game won

first-place honors in the pictorial division at the Second Annual Exhibition of Photography held in 1950 at Southern University in Baton Rouge, Louisiana. The *Arkansas State Press* ran a nice story— "Grice Wins In Photography"—with a picture of the smiling winner surrounded by recent work.

Powerful people had encouraged and assisted him—most obviously Daisy Bates in Little Rock and John Howard in Pine Bluff—but mostly he had made his way by his industry and his talent. He was not yet thirty, ambitious and idealistic—"dedicated to doing something constructive for humanity and myself." And in his own chosen world he was already, in the words of his 1949 wedding announcement, "a photographer of note."

There would be additional big events in his future. In 1953 Mary McLeod Bethune would speak to students at AM&N, and future Supreme Court Justice Thurgood Marshall would address the Arkansas Teachers Association in Little Rock. Martin Luther King Jr. would come to Pine Bluff to deliver the AM&N commencement address in 1958; Ray Charles, Fats Domino, Duke Ellington, and James Brown would play, and Muhammad Ali would serve as a parade marshal.[4] Grice would photograph them all. Up in Little Rock in 1951, he would manage a wonderful picture of a beaming President Harry Truman marching in a parade, despite the fact that as a black photographer he wasn't allowed on the press car.

For each picture there is a story. He remembers Bethune as a powerful speaker and a formidable woman. She "had a direct line to the White House" and "would under no circumstances ever ride in the back seat of any car. I had a Ford Thunderbird then, so when I drove her around there was no problem." Martin Luther King Jr. struck him as "humble," despite his celebrity. "I stayed with him half a day, chatted with him. He was a nice man to talk with." Jesse Jackson, on the other hand, stars in one of Grice's most vivid celebrity stories: "All the preachers had their Cadillacs polished up good, fighting over who got to carry him [Jackson] back up to Little Rock to catch his plane. One Jesse rode with came back mad as hell—said he wouldn't say a word the whole trip!"

4. Dating for many photographs is speculative. I have guessed, for example, that the photograph of Mary McLeod Bethune was made in 1953. A front-page story in the *Arkansas State Press* for April 24, 1953, puts her in Arkansas on April 25. Bethune died in 1955. Similarly, I have guessed that the photograph of Thurgood Marshall dates from the same year, since another front-page *Arkansas State Press* account, dated June 12, 1953, reports Marshall's arrival in Arkansas to address the Arkansas Teachers Association.

The photographs of Bethune, King, and Jackson aside, Grice's involvement with the turbulent period of civil-rights activism was peripheral at best, despite the fact that Pine Bluff and AM&N were in many ways the state's most active centers of resistance to the segregationist order. A thorough history of this period has yet to be written, but even a cursory perusal of the newspapers of the day makes it clear that the well-deserved attention accorded the struggles at Little Rock Central is misleading in at least this regard. Desegregation struggles were waged all over the state, of course, in large towns and in small, but from a 1960 boycott to a 1963 AM&N sit-in to a 1964 public-pool closing and an arrest of activist-comedian Dick Gregory, Pine Bluff stories are at the center of Arkansas's civil-rights struggle.

At one point in our interviews, I went to Pine Bluff with *Pictures Tell the Story,* a beautifully produced collection of the work of Memphis photographer Ernest C. Withers. In many ways, Withers served Memphis as Grice has served Pine Bluff—as the photographic keeper of the African American community's history. Like Grice, Withers ran a commercial studio; like Grice, Withers made many photographs of entertainers, politicians, and athletes. Both men photographed Martin Luther King Jr. and Ray Charles. Shared experiences, in fact, go back to the beginning of their careers—both men were born in 1922 and raised in the South, though the Memphis-born Withers was city bred from the beginning. Both played football and took their first pictures in high school—after borrowing a camera to photograph Joe Louis's wife when she visited, Withers "became the semiofficial photographer at Manassas High."[5] Both men also served in the Pacific during World War II—Withers was in the army and did most of his overseas duty on Saipan. Withers, like many other African American photographers of the period, managed to work as a photographer during his time in the military—Deborah Willis's sweeping history of African American photography, *Reflections in Black,* mentions the wartime experiences of Gordon Parks, Jack Franklin, Eugene Roquemore, and Curtis Humphrey.[6]

But unlike Grice, Withers was also very much at the center of the civil-rights movement; he was, as one of the chapter heads in *Pictures Tell the Story* observes, a "participant photographer." At

5. F. Jack Hurley, Brooks Johnson, and Daniel J. Wolff, *Pictures Tell the Story: Ernest C. Withers Reflections in History* (Norfolk, Virginia: Chrysler Museum of Art, 2000), p. 33.

6. Willis, *Reflections in Black,* pp. 89, 113, 115, 116.

the very beginning of his career he spent a tension-filled week in Sumner, Mississippi, covering the Emmett Till murder trial, and later published at his own expense a booklet entitled *Complete Photo Story of Till Murder Case.* (Nobody mentions it, but this booklet ties Withers very nicely to the oldest activist traditions of African American photography—as far back as 1855, James Presley Ball had produced *Ball's Splendid Mammoth Pictorial Tour of the United States Comprising Views of the African Slave Trade; of Northern and Southern Cities; of Cotton and Sugar Plantations; of the Mississippi, Ohio, and Susquehanna Rivers, Niagara Falls, & C.,* "a pamphlet that addressed the horrors of slavery, from capture in Africa, through the Middle Passage, and then to bondage."[7])

Withers was in Little Rock when the violence at Little Rock Central erupted; he was beaten by police at Medgar Evers's funeral in Jackson, Mississippi; and before that he'd covered the bus boycott in Montgomery, Alabama. Withers, then, was much more than a recorder; he was a civil-rights activist with a camera. Grice was warmly appreciative of Withers's work, but he couldn't have been more emphatic in insisting upon his own very different approach:

> I didn't do any of that. Sure didn't. I knew Withers, met him several times when we were both working. He was a mighty brave man. I didn't want to be a part of that—the police here. I had press cards. It's a different ballgame down here now—chief of police is a black man. But times were rough then—they had a thing here once, had something to do with civil-rights stuff, a shootout down on 3rd and State, place called the Gala Room. They shot the building all up.

This self-appraisal is too modest by half—after all, the 1948 trip up the mountain to Fayetteville in Harold Flowers's little Frazier was no journey for the fainthearted. And there were other times, too, despite Grice's best efforts to sideline himself, when civil-rights issues marched right to his door. Sometime in the 1960s, for example, he was sent to a Pine Bluff funeral home by the widow of a dead man named Cornell Russ. His job was to obtain close-up photographs of her husband's body. "Man was in jail, down in Star City. The sheriff shot him, or maybe it was a deputy. In the jail. Bullet hole right in the middle of his forehead. Claimed he was trying to escape. The family

7. Willis, *Reflections in Black,* p. 7.

hired me. They wanted to make a case against the police." Dead black prisoner shot by a white law officer, black photographer developing tangible evidence, bringing at least unwelcome publicity and at most potential lawsuits—it's not hard to imagine this as a tension-filled assignment.

In addition to the history-making 1948 Fayetteville trip with Silas Hunt and the grisly journey to Tucker to witness the executions of Lawrence Willie Dukes and Cubie Lee Johnson in 1947, Grice also traveled on at least one other occasion to cover an event explicitly connected to civil-rights activities.

> Man called Sweet Willie Wine—he was an activist from Chicago. Maybe he was a Panther Party member, Black Panther, I don't remember. Anyway, he organized a demonstration in Forrest City—"Free Huey" posters, black power salutes. Something to do with voting rights in St. Francis County. He got up some kind of march—Forrest City to the state capital building in Little Rock. First time a lot of people down here ever saw anything like that except on television. I went up and took pictures—I don't know if I had any chance to sell them to the papers. The *State Press* wasn't publishing then, I don't think.

But despite such moments, the basic observation holds—Grice and his camera were conspicuously absent from the scene when the great civil-rights struggles erupted on the streets of Pine Bluff, Little Rock, and other Arkansas cities. An offhand remark by Henri Linton, made late at night in his office when we were marveling together at the sheer volume and range of Grice's work, is in fundamental agreement with Grice's own assessment. "Man shot everything that moved or sat still," I said. "Everything but the civil-rights movement," Linton replied.

His service had a different focus. If he missed the spectacular eruptions that refashioned the basic structures of local life, he was indefatigable in his chronicling of that life's features. Once he'd opened up his own commercial studio at Fourth and Main in downtown Pine Bluff, he would spend more than forty years earning his living making pictures of everything his customers wanted recorded—their weddings and funerals, their new babies and proud graduates, birth and death and all the important occasions between. Most of his work and most of his income came from day-to-day work with the citizens of southeast Arkansas, especially the African American citizens. He took shots of wrecked cars and burned houses for local attorneys and insurance

agents. He photographed smiling employees and store facades for local grocery stores and car dealers. Year after year, he showed up with his camera at music-school recitals, high-school proms, school-group conventions, and businessmen's luncheons. Weekend nights he set up shop at PJ's Lounge and sold Polaroid shots of citizens at play.

Grice worked, more than most photographers, in a world he knew intimately—as campus photographer at AM&N, he was working for the school where he'd been a student; shooting for the *Arkansas State Press*, he was working in the town where he went to high school, for the paper that published his Dunbar gossip column. When he photographs a group of balloon-toting children at a birthday party, his son is among the celebrants. When he photographs a rural funeral in Phoenix, Arkansas, he's in a cemetery where two of his grandparents are buried. And it is here, in this work, even more than with his spectacular Chicago photographs of Louis Armstrong, Eleanor Roosevelt, or Joe Louis, that Geleve Grice earns his little niche of immortality. Other photographers, after all, were on hand to record the appearances of famous athletic, entertainment, and political personalities. But in the Arkansas world where he was himself at home, and where he worked so diligently over so many years, Grice was in most instances the only photographer who found the scenes before him compelling, worthy of recording. That now largely vanished social order finds its most vivid and enduring record in the hundreds upon hundreds of images he made. If he's not there, on the job, camera at the ready, it's mostly lost. This is how it was, in this place at this time, is time after time the underlying message. These are our good times and our grievings, our parties and our funerals, the work and the play of our whole world, from professional elites to ordinary working folks.

It's all here, one image upon another in dizzying profusion. Looking at it whole can be an overwhelming experience. Sometimes it leaves a bitter taste. A 1960s photograph of an AM&N Board of Trustees meeting, for example, shows the six trustees, all male, all white, relaxing around a table in their shirt sleeves. It's understood that these men are doing good work. They're not Kluxer monsters; they wouldn't be serving if they didn't support higher education for the state's best and brightest African American students. But standing behind them, not seated with them, his coat still on, looking for all the world like a waiter, is Lawrence Davis, the university president. A more succinct image of a deeply entrenched segregationist regime would be difficult to conjure.

The school pictures might be read in an even bleaker light. The hundreds upon hundreds of proud graduates and prom dancers are draped in their robes and mortar boards, arranged in couples in their tuxedos and formal dresses, posed in the composite class pictures with their hopeful mottoes—"Impossible Is Un American," says Eudora's class of 1954. But look at the years of these photographs; note that long after 1954 these remain wholly segregated and woefully underfunded schools in some of the state's poorest communities, and the hopeful mottoes start to look like cynical jokes played upon the proud and determined young faces.

At other times the sheer volume of Mr. Grice's archive can provoke a happier response. The scores of standard funeral shots, the deceased citizen laid out in the best state his or her survivors can afford, match up against other scores of baby portraits, the infants and toddlers togged out in the best their proud parents can afford, smiling from couches and chairs for the man with the camera. Take it all together and the whole fabric renews itself, reknits in the mind, convinces the viewer that in the constant shuttling of funerals and births the community not only sustains itself, but shows itself as stronger than it might appear in any single image. One high-school class with its touchingly hopeful motto seems unbearably fragile; fifty high-school classes, hundreds upon hundreds of beautiful, strong faces, appear downright invincible.

Even with this deep immersion in a local world, there were times when Grice cast a somewhat wider net. Each year, for example, in the 1950s, 1960s, and early 1970s, he crisscrossed the state carrying his own collection of caps and gowns, shooting class pictures and senior portraits at the black schools. Thousands of these photographs remain in his collection today.

That was hard work, it really was. Drove all over the state—Fort Smith, Clarksville, Lonoke, Texarkana. I went as far west as Tyler, Texas. I'd put 'em in caps and gowns in October. You know, I couldn't get everywhere in April and May. I was trying to make a living, but it was hard. Those people didn't have much money anyway—I've still got hundreds and hundreds of little wallet-size prints people ordered but never paid for. Lots of times you wouldn't get done, have to stay over in a motel. But kids in the black schools knew that kids in the white schools had prom photos and graduation pictures, and they wanted them too. Same with the parents. I knew if I didn't do it nobody else would. Sometimes they'd pay part of the cost when I took the pictures and send me the rest

later. Sometimes it took months—then I'd get a letter with a three-dollar money order, send them the prints. I did a lot of C.O.D. business in those days. When integration finally came, it pretty much cut me out of the school-picture business—white photographers got it all. I was all for it anyway, of course. You wouldn't believe how poor those old schools were—lot of times all the furniture and books they got were what the white schools threw out.

Other jobs took him to other places—he accompanied the AM&N choir on a tour to Chicago; he journeyed to Atlanta when AM&N President Lawrence Davis received an honorary degree from Morehouse College.

On the way back from Atlanta I took a picture of a laundry sign. Never will forget it—little town near Birmingham. Place called Imperial Laundry, had a big sign: "We Wash for White People Only." Birmingham was a scary place back then—black people called it "Bombingham." We rolled the window down, drove by as slowly as the driver was willing. I snuck a picture while nobody was looking.

On another occasion he traveled to Hot Springs to photograph the annual meeting of the Arkansas Teachers Association. "Teachers were segregated in those days, too, just like students. Every year the black teachers held their meeting at the Baptist Hotel in Hot Springs—started getting ready soon as school started in the fall. Lot of women in fine clothes and new hats at that meeting."

In this itinerancy, of course, especially in the travels as a school photographer, Grice's practice harks back to the earliest American photographic traditions, where "traveling daguerreotypists set up their cameras in rented rooms, or drove their wagon-studios into town and set up temporary portrait studios in public areas."[8] The earliest African American photographers, in particular, were often extraordinarily mobile—and many of their movements were driven by race as a factor. Augustus Washington, a fervent abolitionist (his work includes a striking daguerreotype portrait of John Brown), opened his first studio in Hartford, Connecticut in the 1840s. Despairing of the prospects for African Americans in the United States, however, he moved often

8. Willis, *Reflections in Black,* p. 5.

and eventually ended up in Liberia. The Goodridge brothers (Glenalvin, Wallace, and William) established themselves in York, Pennsylvania, in the 1850s, but their active involvement with the Underground Railroad forced a move to Saginaw, Michigan, in 1863.[9] James Presley Ball's career was even more spectacularly peripatetic, though his moves seem entirely voluntary and motivated more by opportunity than by despair. Ball opened his first studio in Cincinnati in the 1840s, but before his death (in Hawaii!) in 1904 he had also set up shop in Virginia (Richmond), Minnesota (Minneapolis), Montana (Helena), and Washington (Seattle).

Unlike these pioneers, Grice always did his traveling from a well-established home base, firmly rooted in Pine Bluff. His most obvious predecessors in the African American photographic tradition would be practitioners like the already mentioned Addison Scurlock and Paul Poole, or Harry Shepherd, whose studio in St. Paul, Minnesota, opened in 1887 and operated for at least eighteen years, or Daniel Freeman, who worked in Washington, D.C., from 1885 until 1917 or later, or (even more durably) the Richmond, Virginia, business of George O. Brown and his descendants. "The Brown family studio, operated by his son and daughter after his death, was prominent in Richmond from 1875 to 1977."[10]

In addition to the school portraits and his studio business, Grice also continued to do photojournalistic work for the *Arkansas State Press* and for television stations KARK and KHTV. His bylined photos appear regularly throughout the early and middle 1950s—there are at least ten in the *Arkansas State Press* in 1951, and eight as late as 1956. But over and above all this work, and all the studio work done to the order of clients, he was making hundreds upon hundreds of pictures every year for which he had no expectation of a market. He took pictures of buildings and fields, of glamorous formal parties at AM&N and farmer laborers relaxing at ramshackle country stores, of rural and small-town families at work and play, of farm equipment and industrial mills and factories, of ships and airplanes, of parades and festivals, of vegetables from his own garden.

If Geleve Grice made his living taking pictures for others, he made his own life making photographs, thousands and thousands of photographs, for himself. The black and white prints

9. A thorough history of the Goodridge Brothers and their work is John Jezierski, *Enterprising Images: The Goodridge Brothers, African American Photographers, 1847–1922* (Detroit: Wayne State University Press, 2000).
10. Willis, *Reflections in Black,* p. 14.

from his bulky Speed Graphics gradually give way to slides and color prints from new favorite 35 mm Leicas and Nikons, but the fundamental impulse to "do something constructive for humanity and myself" by making pictures never wavers. Making pictures was the primary impulse—selling them was secondary. The wonderful images from 1943, after all, pictures of Joe Louis and Louis Armstrong and T-Bone Walker, were obviously marketable, but no commercial interest inspired their making; he never tried to sell them, and in fact they waited more than half a century for their first public showing.

That came in 1998, when Henri Linton assembled "Those Who Dare To Dream: The Works of Arkansas Photographer Geleve Grice" at the University of Arkansas at Pine Bluff. That was a fine show; without it I would never have gotten the call from Michael Dabrishus, and this collection would not exist. But for Geleve Grice himself, getting the work done and getting it into the hands of its intended audiences was itself sufficient, the completion of the only circuit he really cared about. His modest larger celebrity is very much an accident, which he accepts with grace and aplomb but to which his deepest response seems to be bemusement.

Grice does, however, possess a genuine if sporadically active entrepreneurial streak—through most of the 1960s he operated a combination nightclub/restaurant called Grice's Supper Club in Pine Bluff, and in the 1980s he devoted considerable energy to several unsuccessful attempts to market menu and advertising photos of food displays. Grice's son Michael still has vivid memories of Grice's Supper Club:

> I was just a kid, but I loved to spend time there. There was a big neon sign, dining room up in front, live music and dancing in the back. Dad cooked sometimes, other times just greeted people when they came in. When he had to he could be a kind of bouncer—one time he pulled his .38 on some guys who got rowdy. It wasn't a honky-tonk in any way—people dressed up, came in from Stuttgart, Little Rock, all over. Dad expanded it twice, but he could never get the owners to sell it to him. I think that's why he finally closed it down.

The food photographs came later; Grice still has scores of images of loaded plates with one identifiable product in the setting—a Budweiser beer, some A-1 steak sauce, a can of Pepsi. "I got

a lot of nice letters back, but I never sold a one," he says. "All those big companies had their own advertising sections. They did their own photographs and layouts. I did always get to eat the food."

"Those Who Dare to Dream," for its part, understandably focused attention on images of famous people, figures and events associated with UAPB. But it did include a straightforward portrait of a farm family from Elaine, Arkansas, posed standing on their porch, that reveals the surrounding photographs of luminaries to be only one facet, and not at last the most significant facet, of his lifelong work. It was my first hint that Geleve Grice, in fact, had documented the whole spectrum of life in Pine Bluff and southeast Arkansas, and especially the life of the region's African American citizens, just as Ernest Withers preserved the fabric of life in the black community of Memphis; just as Michael Disfarmer and F. S. McKnight, working in Heber Springs, Arkansas, and Aberdeen, Mississippi, recorded rich accounts of life in those communities; just as James VanDerZee saved a magnificent record of Harlem's much larger community; and just as Roman Vishniac, on the very eve of Hitler's genocidal assault, chronicled the doomed Jewish communities of Eastern Europe.[11]

All these comparisons are haphazard examples, chosen nearly at random except for the deliberate ranging from the local to the international, and they bring together photographers whose motives and procedures are in many respects strikingly different. Vishniac was a very conscious recorder of a threatened community; he operated in haste and at considerable personal risk to accomplish his work. Disfarmer's very different interest is centered on formal studio portraits. But the real point is that all such work is undertaken in response to one impulse, finally, whoever initiates its accomplishment, whatever the locale, whatever tool—pen, paintbrush, camera—the artist employs. The recorded scene or event is alleged, by the effort expended in accomplishing

11. For the work of Mike Disfarmer, see Julia Scully, *Disfarmer: The Heber Springs Portraits 1939–1946* (Danbury, N.H.: Addison House, 1976) and Toba Pato Tucker, *Heber Springs Portraits: Continuity and Change in the World Disfarmer Photographed* (Albuquerque: University of New Mexico Press, 1996). For F. S. McKnight see "The Studio Photography of F. S. McKnight," *The Oxford American* 24 (November/December, 1998): 35–45. For James VanDerZee's work see Deborah Willis-Braithwaite, *VanDerZee: Photographer, 1886–1983* (New York: Harry N. Abrams, 1993). For Roman Vishniac, see Marion Wiesel, ed., *To Give Them Light: The Legacy of Roman Vishniac* (New York: Simon and Schuster, 1993).

the history, the painting, the photograph, to possess beauty, meaning, significance, dignity—some form of *value*. It claimed at least somebody's attention, perhaps even someone's devotion. Its utter oblivion is by the initiative of this attention or devotion averted. In the thousands of photographs accomplished in Pine Bluff by Geleve Grice over the last half century, the whole range of community life is captured. There are shots from the very top of the social and economic ladder: one sees President Lawrence Davis and his wife receiving guests at an elegant reception, academics in their suits posed proudly at the entrance to the agriculture building, basketball stars Todd Day and Darrell Walker relaxing at PJ's lounge. Balancing these are images of people up against it: a tired man drinking beer and smoking in a lounge far less opulent than PJ's, a group of men playing checkers, a family lined up outside their home near Elaine. It's all there—top to bottom and all the rungs in the middle—thanks to Geleve Grice's lifelong vocation.

In even the sunniest of times, disaster for the moment at bay, the fabric of town and country life is transient. Mortal features of loved faces, the streets and structures of loved towns, shift before our eyes. All is soon lost, no matter how familiar, unless someone acts to save, to record, to preserve. Mike Disfarmer, working in obscurity in the 1930s and 1940s, left as his enduring legacy a series of riveting portraits allowing the residents of a Cleburne County resort town to address across the years audiences far from the hills of north central Arkansas. Geleve Grice, beginning his work in another part of Arkansas at about the time Disfarmer was ending his, has provided a no-less-commanding chronicle of the world he knows. In the work of both men the life of Arkansas communities is not only preserved but also somehow heightened, composed to an archetypal stillness by the artistry of the photographers who found it compelling. The work of an instant's fleeting light, the photograph's image, no matter how apparently modest or unprepossessing, no matter how merely competent its technical execution, lifts toward art's duration and poise. Forged of time's energy, it resists time's entropy.[12]

12. The most intelligent analysis of "folk art" I know is Henry Glassie's. My responses to Mr. Grice's photographs are my own, of course, but it remains true that having written them down I returned, again, to Glassie's work, especially *The Spirit of Folk Art* (New York: Harry N. Abrams, 1989), just to be reassured that it was not only permissible but necessary to accord the close attention often reserved for self-consciously "artistic" productions to apparently "utilitarian" commercial productions as well. And I was.

Words, of course, do not quite capture this—the peculiar dignity of a photograph is at last wholly visual, not verbal. But look carefully, just for example, at two of this collection's images, chosen with barely a moment's deliberation; any number of others would have served as well. "Davy Crockett (Michael Grice) and friend" shows two children, one the son of the photographer, the other unidentified. But look how proudly he wears his Crockett coonskin cap and his empty holster. He possesses ferocious gear, but he's a child, and a happy child at that. His face is effulgent with childhood's security. And his friend—look how she holds his hand, leans her head toward his. Her face is no less serene.

"Levi Flentroy funeral, Phoenix, Arkansas" is of course very different. It's a burial scene; a humble box is headed into humble ground. The earth is muddy, leafless branches angle across a gray sky, an incongruous old tire occupies the very center of the photograph. But somehow this photograph, like the Edenic image of the children, manages its own sense of community. Eight men, pallbearers, are out in the rain, working against the elements to give their friend a decent burial—they bend to him, extend their hands, much as the little girl bends her head to young Michael Grice and unselfconsciously holds his hand. At the heart of both photographs, underlying their obvious differences, is a shared expression of social bond, of connection. Artless and unthreatened in the one instance, subjected to nearly cosmic assault in the other, it remains unbroken in both.

Recognizing this, we reach very close to Grice's most characteristic artistic signature. It was there from the beginning, too. Given a chance to photograph Joe Louis, Grice lines him up with a group of beauties, sits him at a table with fans, stands him behind another table. Same thing with Louis Armstrong. T-Bone Walker is an exception, at least in some of the shots, but again and again Grice's compositional choice is to group his subjects, capture them in more or less intimate association. "Three men at baseball game," to indulge one more example, is a delicately effective photograph—the spacing, the suits, the hands clasped on ankles or between knees. The men may (or may not) have arrived separately, as strangers, but as spectators they have been drawn into association, even to the point of adjusting their postures one to the other, and the photograph centers its appeal in its framing of their association, their wonderfully nuanced attitudes of connection.

In the *Arkansas Historical Quarterly* article, editor Williams placed the photographs of the farm family near Elaine and the group of teachers gathered for a meeting in Hot Springs on facing pages. Perhaps he did this on formal grounds—both shots are straight-on frontal portraits; the subjects are lined up flanked by columns at the entrance of buildings. The teachers are well-dressed professionals—they look good, and they know it. Most of the seven are smiling openly. The farm family is very different. Their clothes are barely functional—patched, threadbare, ill-fitting. These folks are up against it. Not one of the nine, children or adult, is smiling.

But again, as with the photographs of the happy children and the bad-weather funeral, or with the men at the ball game, these differences are more than matched by a shared emphasis on association, on social tie. The fundamental similarity is more than formal—in both instances, again, these are portraits of people linked to one another, by family ties in the one instance and professional association in the other. We seven, we nine. We. Over and over, sometimes openly and sometimes implicitly, Geleve Grice's photographs focus their attention upon communities, large and small, upon moments that are above all shared.

The same impulse is no less prominent in the collection of photographs of Dr. Martin Luther King Jr. Here, in perhaps the single most important photographic assignment of his career at AM&N, Grice once again chose to portray the great civil-rights leader mostly in moments of intimate interaction with admiring students and townspeople. He made the requisite formal shots of course—of the speaker at the podium, of the speaker with the university president. (And the one formal individual portrait is a strikingly effective shot—no image I know conveys a stronger sense of King's unflinching *strength*. He's looking straight into the camera, unsmiling, one hand in his suit pocket, the other loose at his side. The sense is that of a sturdy, compact man, absolutely fearless, calm in his readiness for whatever might come.) But then look at the informal shots, notice how often Dr. King is smiling, and notice even more how many of the people around him are also smiling. Smiling very broadly. He's signing their programs, they're shaking his hand, and once again Geleve Grice has captured wonderful moments of association, of a much admired visitor and a grateful community happy in their time together.

The appeal of most commercial work might seem at first to be limited to those who com-

mission it—wedding photographs are valued by the bride and groom and their families, graduation portraits by the diploma holders and their parents. The photographer in these circumstances may be activated not by documentary or artistic purposes but by wholly pecuniary ones. Each portrait, each event, is approached as a separate, self-contained "job" by the photographer, and appreciated entirely for itself by the subject/customer. For the client, as for the photographer, such work seems at the time to be a part of no larger enterprise. Everything changes, however, when these same photographs are examined, often much later, by third parties outside the original transaction, who approach them from other perspectives or with different interests. Two of these novel perspectives or interests seem especially common: the new viewer may, on the one hand, intensify her or his interest in the photograph as an artifact, a composition, a result of choices and actions by its maker; the new viewer may, on the other hand, intensify her or his interest not in the photograph itself but in its subject, seen now not primarily as a unique individual but as somehow characteristic or typical of a given social or historical milieu. For the one viewer, appreciation of the photograph is thus enhanced as a work of art; for the other, it is enhanced as a social or historical document.

When Michael Lesy, for example, studied some three thousand photographs made by Charles J. Van Schaick between 1885 and 1942 in Black River Falls, Wisconsin, he was convinced that taken together these commercial photographs made in response to private initiatives might offer useful information "not only about the town of Black River Falls, county of Jackson, state of Wisconsin, but about the entire region and era in which the town, county, and state were enmeshed."[13] Gathering approximately 5 percent of these photographs, juxtaposing them with contemporary newspaper accounts and occasional literary excerpts, Lesy completed a Ph.D. dissertation and a marvelously eccentric book, *Wisconsin Death Trip*. In this move the individual photographs—in Grice's case, for example, of beauty contest winners or of children in a Christmas pageant—sacrifice much of their original appeal. The first was probably intended for the editors and readers of the *Arkansas State Press*; the second for the parents of the children. The

13. Michael Lesy, *Wisconsin Death Trip* (1973; reprint, Albuquerque: University of New Mexico Press, 2000), p. 9.

new viewers, folks interested in something approximating "the entire region and era," are often unrelated to the beauties or the children.

What's gained in recompense is an interest focused on the representative character of both photographs. Even viewers at great distance recognize the existence of beauty contests and Christmas pageants, are quick to relate them to similar festivals from their own times and places. Similarly, the photograph of one small-town high-school basketball team restores a world familiar to many who could identify neither the players nor the locale—they recognize instead from their own analogous experiences the now-obsolete footwear, the proximity of the wall to the sideline, the formal I-am-a-molder-of-men expression of the coach standing in his coat and tie at the rear. For these, the photograph may now possess a new power, despite its mix of private, topical, and commercial origins. The gaze of more distant eyes may combine with the sheer passage of time to confer that aura of archetypal sublimity we associate with art upon even the most humble photographic record of quotidian life, memorialized either for money at the initiative of that life's actors or for personal satisfaction at the initiative of the photographer.[14]

14. This whole notion runs directly counter to well-known modernist analyses of "aura" in photography—Walter Benjamin's "The Work of Art in the Age of Mechanical Reproduction" (1936), and Theodor Adorno's response, "On the Fetish Character of Music and the Regression of Listening" (1938), are especially famous essays. Benjamin and Adorno, whatever their disagreements, shared a profound hostility to the new technologies that made phonographic and photographic reproduction possible: for them the power or "aura" of artistic productions is rooted in a quasi-religious ritual function characterized by infrequent exhibition/performance. Tied to the sacred space of the temple and the sacred time of the ritual calendar, works of art were in their origins "instruments of magic." Their "cult value" is gradually displaced by "exhibition value" when they are freed into the enhanced mobility and visibility that accompanied their gradual secularization. "Mechanical reproduction" is for Benjamin and Adorno a final stage in this "regression." It seems clear that one might easily put forward a nearly opposite argument—that photographic (and/or cinematic) images often possess enormous "aura"—the Civil War images of Matthew Brady and the Native American portraits of Edward S. Curtis are just two obvious examples. It might be argued, in fact, that the seeming mystery of new technologies of "mechanical reproduction" may actually contribute to or augment "aura," rather than diluting or destroying it. My central point, however, may be in fundamental agreement with Benjamin's analysis in associating "aura" fundamentally with unfamiliarity; the suggestion is that over time the dominant "exhibition value" of the photograph may be supplemented by a renascent "cult value" or "aura" as the initial context of the image's making becomes (temporally, spatially, culturally) increasingly remote. Walter Benjamin, "The Work of Art in the Age of Mechanical Reproduction," in *Illuminations*, ed. Hannah Arendt, trans. Harry Zohn (New York: Schocken Books, 1968), p. 225.

Geleve Grice entered photographs in contests, but artistic imperatives play at best a miniscule role in his work—a photographer less interested in the niceties of developing and printing would be difficult to imagine. He is almost a pure shooter; he worked from the beginning in the world of news and public relations photography, and his later commercial employment was quite similar in its basic operating premises—when he succeeded in his work, editors and school administrators and paying customers were pleased. A wider range of appreciation emerges only later, when many separate images produced in response to enormously varied topical motives are brought together. Only then, when the individual image finds a place in a larger mosaic, do separate images of morning, noon, and evening manage by their combination a portrait of the day, or images of summer and spring join with those of winter and fall to compose a portrait of the year. By this process, a mix of accumulation, juxtaposition, and the passage of time, the routine, competent productions of the working photographer may acquire a wider appeal and a larger interest.

For many photographers, especially those who operate commercial studios in cities and towns far from artistic and cultural centers, the work of preservation that they consciously or unconsciously perform characteristically requires the intervention of another for its completion. Mike Disfarmer waited a long time for recognition—too long. He died before it arrived. James VanDerZee fared a little better—he worked in New York and lived a long time. By the time he died in 1983 at the age of ninety-five, he was famous; Reginald McGhee had recovered his negatives in a studio back room in 1967 and in 1969 Grove Press had published his *The World of James VanDerZee: A Visual Record of Black Americans*. Disfarmer's work was first brought to the attention of a larger audience in 1976 when Julia Scully's *Disfarmer: The Heber Springs Portraits 1939–1946* printed sixty of his approximately three thousand negatives.

Reginald McGhee, Julia Scully—without them who knows what would have happened to the now-treasured images made by VanDerZee and Disfarmer? For Geleve Grice the comparable figure is Henri Linton, of course; without his insight and initiative there is every reason to believe that Grice's thousands of negatives would even now be slowly deteriorating in the sheds behind his Pine Bluff home. But instead a good percentage has been examined, and a sampling of the best has been reprinted, mounted, exhibited, and published. He's a lucky artist, closer to VanDerZee than to Disfarmer. His archive probably contains something like thirty times as many shots as the Disfarmer collection, and he's still shooting.

In February 1999, soon after we'd met, Grice returned from his annual trip to Hawaii (he visits his brother Toy and takes in the Pro Bowl) with more than one hundred photographs, shots of everything from Pearl Harbor memorials and NFL players to street scenes and cloud formations shot from the plane. He's eighty now, but he still manifests a young man's enthusiasm when he has new pictures to show. And the photographs themselves, of his brother and his family, of the NFL stars decked in leis signing autographs for fans—they were produced in fulfillment of the same impulses that drove him sixty years ago to line up Joe Louis and Louis Armstrong with patrons and fans in that Chicago USO club. What I learned, sitting beside him on his couch looking at every one of them, hearing his accounts of their subjects, the events they portrayed, the conditions of their making, had more to do with Mr. Grice himself than with the pictures. What a marvel, I thought, listening to the obvious pleasure in his voice. A true vocation is a good thing to have, by all the evidence—good for the work itself, good for the man or woman who accomplishes it. Had photography been just a job, just a way to pay the bills, his last photographs would have been made years, perhaps decades ago. And even before that, if he'd limited himself to the shots that would pay, the photographs made to the order of customers or editors, hundreds and hundreds of the images I've been poring over these last few years would have never been made.

Finally, then, it all comes together: the long-sustained, competent journeyman's work, professional and avocational, in the first place; its assembly and display in the new context of UAPB's art gallery thanks to the initiative of Henri Linton in the second; and the interest and commitment of the University of Arkansas Press in the third. Surely it's high time now for the belated applause that greeted the publication of Mike Disfarmer's portraits to also sound for Geleve Grice, son of Tamo, Little Rock, and Pine Bluff, noted photographer of Arkansas life.

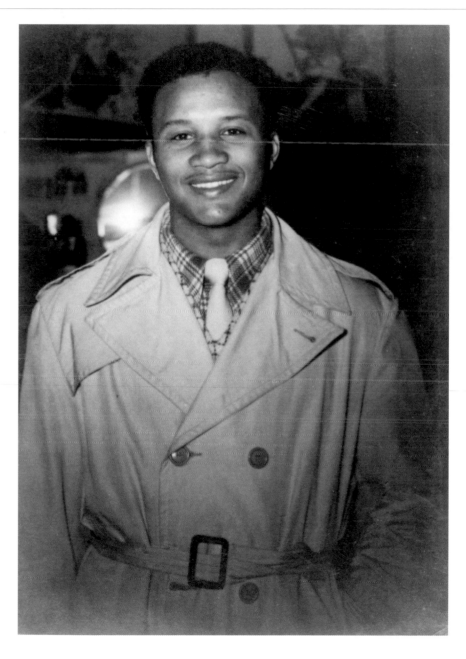

Geleve Grice as an AM&N
student, Pine Bluff, 1947.
Arkansas State Press photogra-
pher. Photographer unknown.

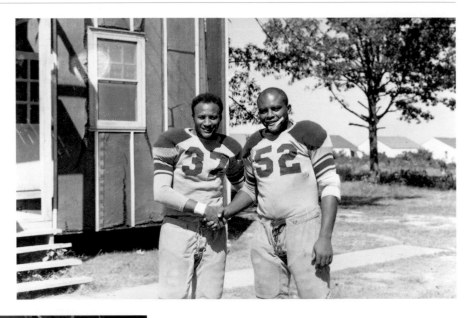

AM&N football players, Pine Bluff, 1947. Geleve Grice *at left*. Photographer unknown.

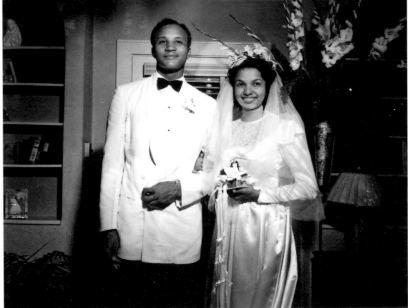

Bride and groom, Little Rock, 1949. Geleve Grice and Jean Bell Grice. Photograph by Earl Davey.

John Howard, Pine Bluff, ca. 1950.

Daisy Bates, Mitchellville, Arkansas, 1960s.

Mary McLeod Bethune and AM&N
President Lawrence Davis, Pine Bluff, 1953.

Mary McLeod Bethune and Mrs. J. B. Watson,
Pine Bluff, 1953.

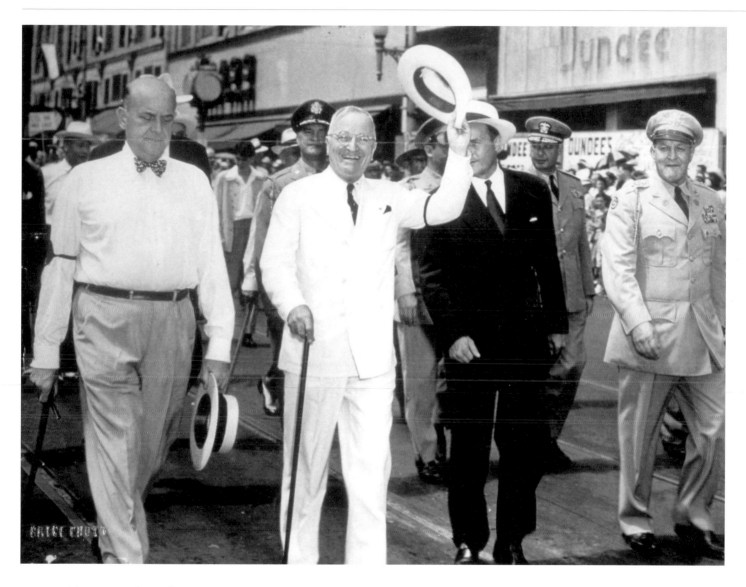

Harry S. Truman, Little Rock, 1951.

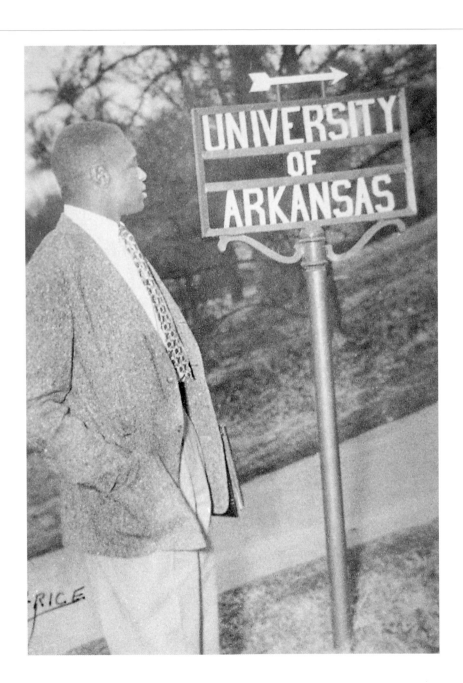

Silas Hunt, Fayetteville, 1948.

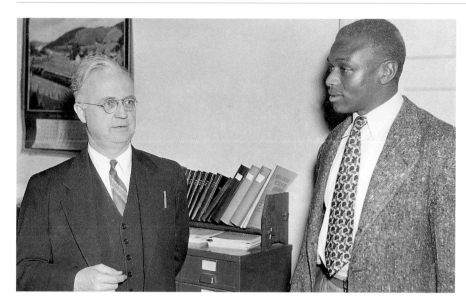

Silas Hunt, Fayetteville, 1948,
with University of Arkansas
Registrar Frederick Kerr.

Silas Hunt, Fayetteville,
1948. Wiley Branton *left*,
Silas Hunt *seated*, Harold
Flowers *right*.

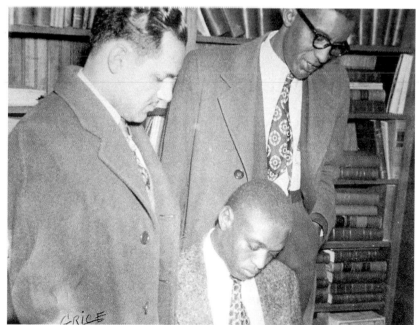

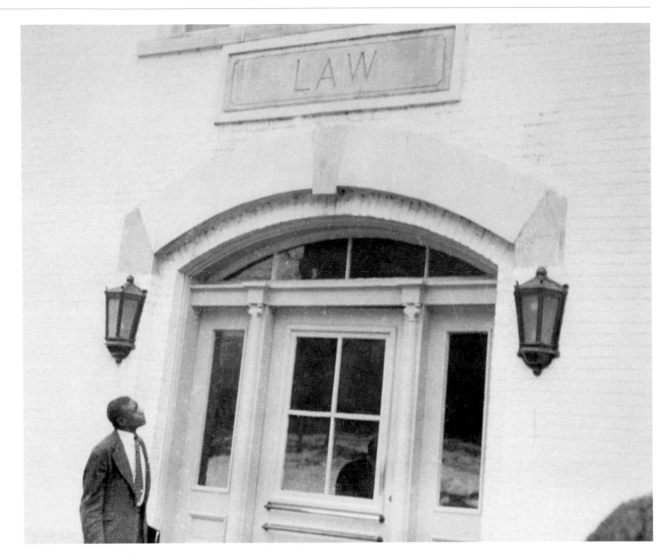

Silas Hunt, Fayetteville, 1948.

Thurgood Marshall, Little Rock or Pine Bluff, 1953. Marshall *standing*; Harold Flowers *seated at left*.

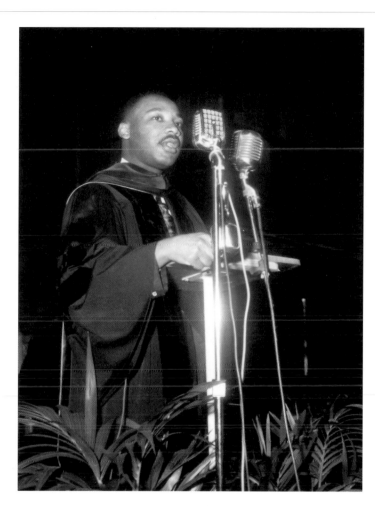

Martin Luther King Jr., Pine Bluff, 1958.

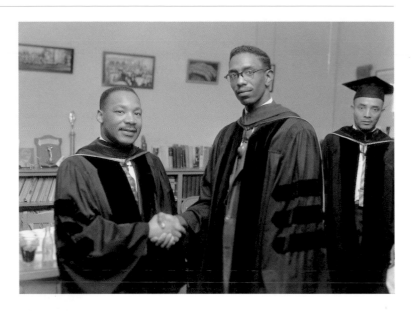

Martin Luther King Jr.,
Pine Bluff, 1958.

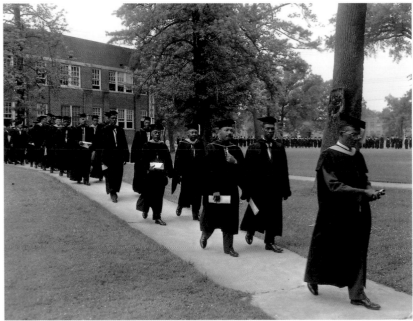

Commencement procession,
Martin Luther King Jr., Pine
Bluff, 1958.

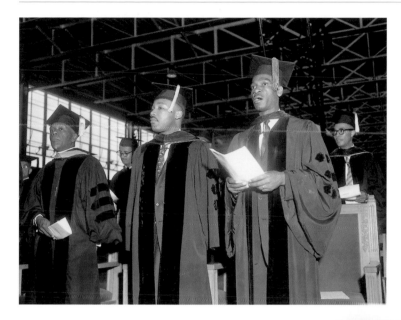

Martin Luther King Jr.,
Pine Bluff, 1958.

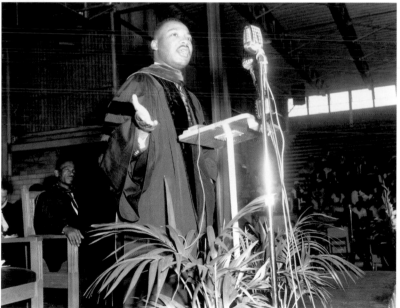

Martin Luther King Jr.,
Pine Bluff, 1958.

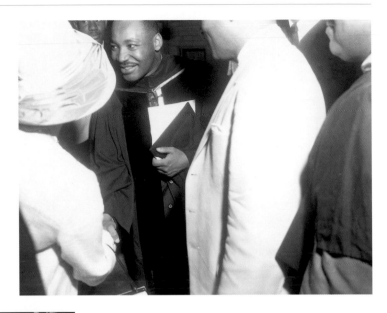

Martin Luther King Jr.,
Pine Bluff, 1958.

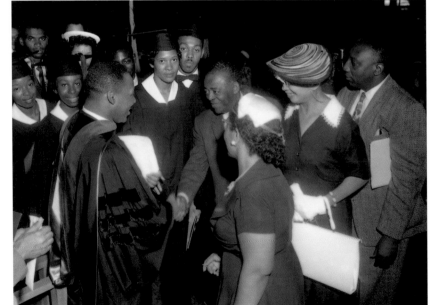

Martin Luther King Jr.,
Pine Bluff, 1958.

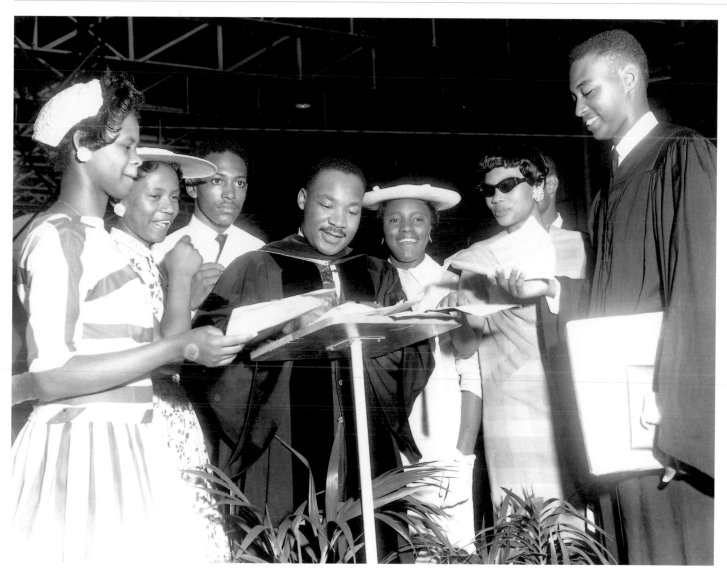

AM&N students with Martin Luther King Jr., Pine Bluff, 1958.

Martin Luther King Jr.,
Pine Bluff, 1958.

Orval Faubus, Pine Bluff,
ca. 1960.

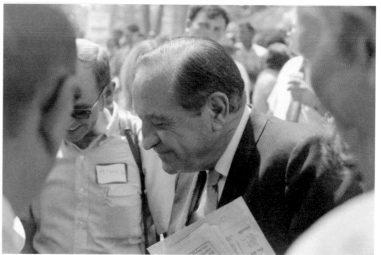

Orval Faubus campaigning,
Pine Bluff, ca. 1960.

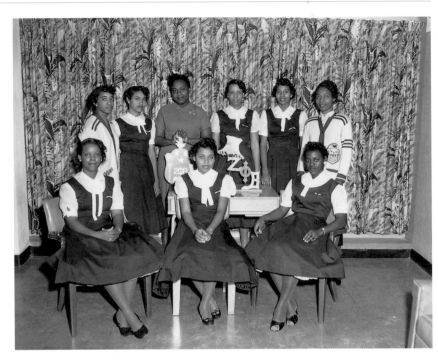

Zeta Phi Beta, Pine Bluff, 1960s.

Freedom from prejudice,
Pine Bluff, 1960s.

AM&N physics class,
Pine Bluff, 1960s.

AM&N biology class,
Pine Bluff, 1960s.

AM&N baseball players, 1960s.

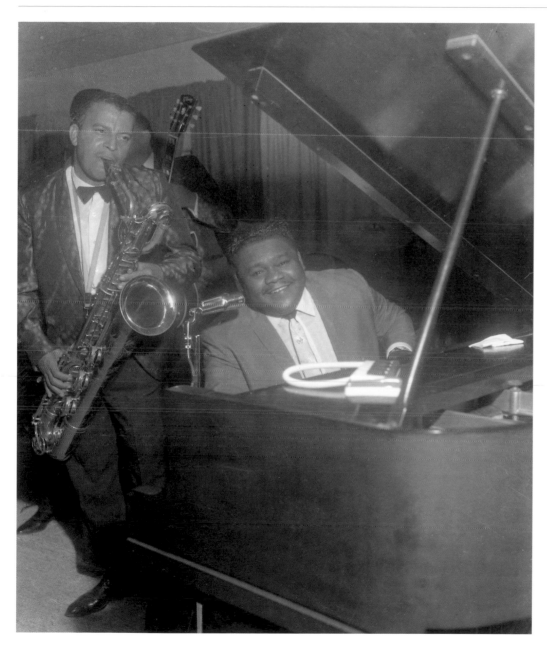

Fats Domino, Gala Room,
Pine Bluff, 1960s.

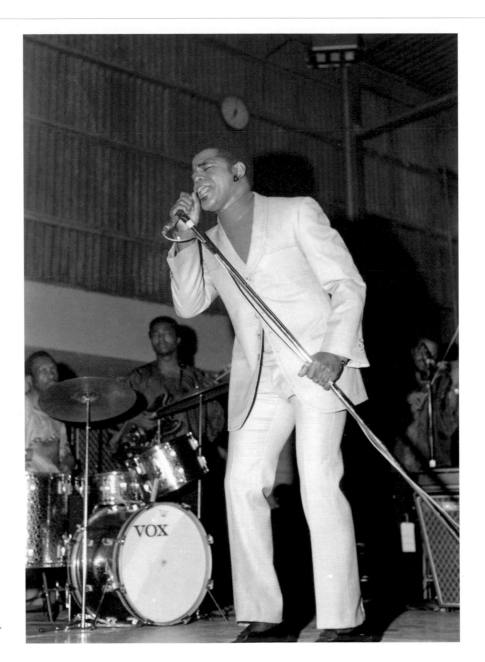

James Brown, Pine Bluff, 1960s.

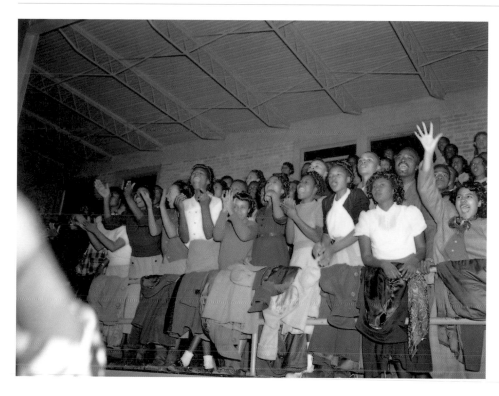

Varied emotions,
Pine Bluff, 1950s.

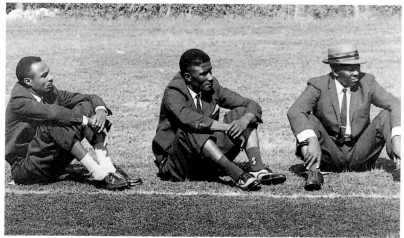

Three men at baseball game,
Pine Bluff, 1960s.

Reception at AM&N President Lawrence Davis's home, Pine Bluff, 1960s.

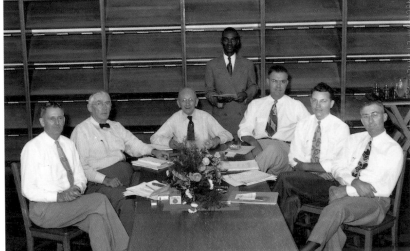

AM&N Board of Trustees meeting, Pine Bluff, 1960s.

President Davis sees off visiting dignitaries, Pine Bluff, 1960s.

Arkansas Teachers Association meeting, Hot Springs, Arkansas, 1960s.

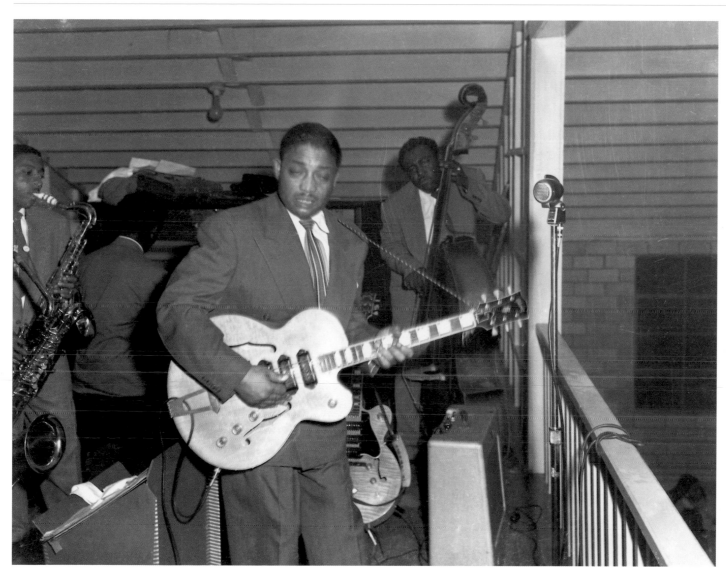

Lowell Fulson, Pine Bluff, 1950s.

Back-to-school dance,
Pine Bluff, 1950s.

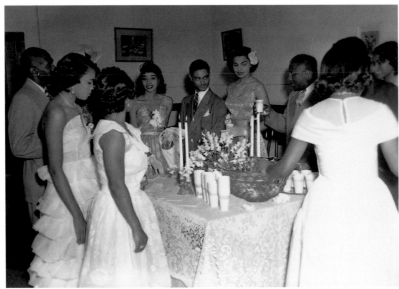

Formal reception,
Pine Bluff, 1960s.

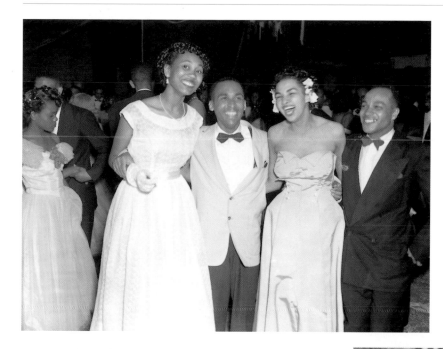

Two couples at dance,
Pine Bluff, 1960s.

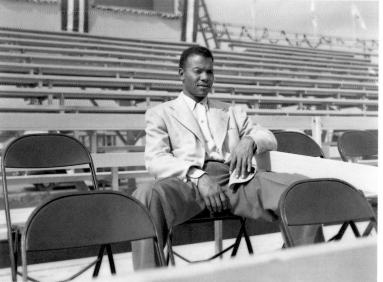

Toy Grice in football stadium,
Pine Bluff, 1950s.

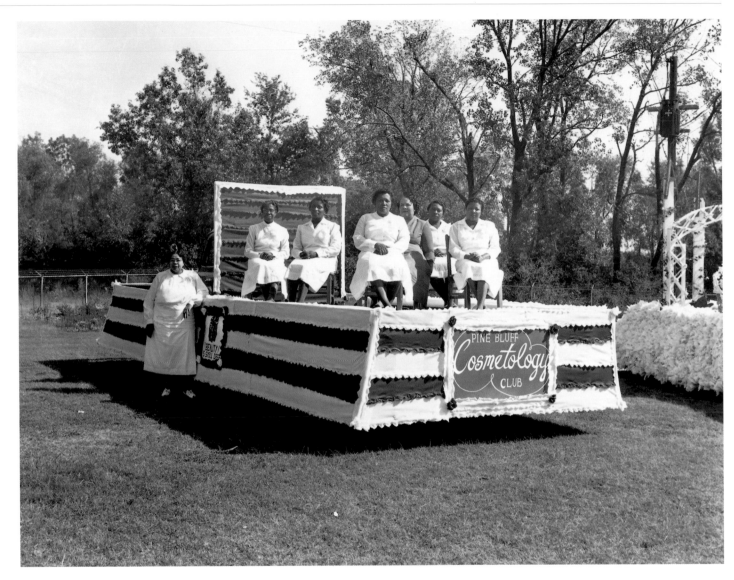

Cosmetology Club parade float, Pine Bluff, 1950s.

"Worried Look," Pine Bluff,
1960s.

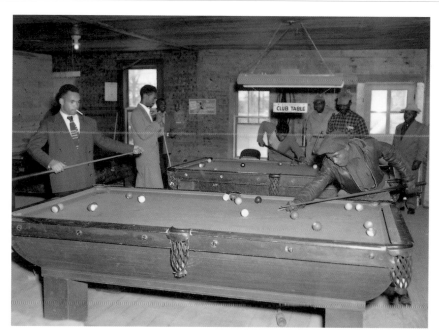

Club table, Pine
Bluff, 1950s.

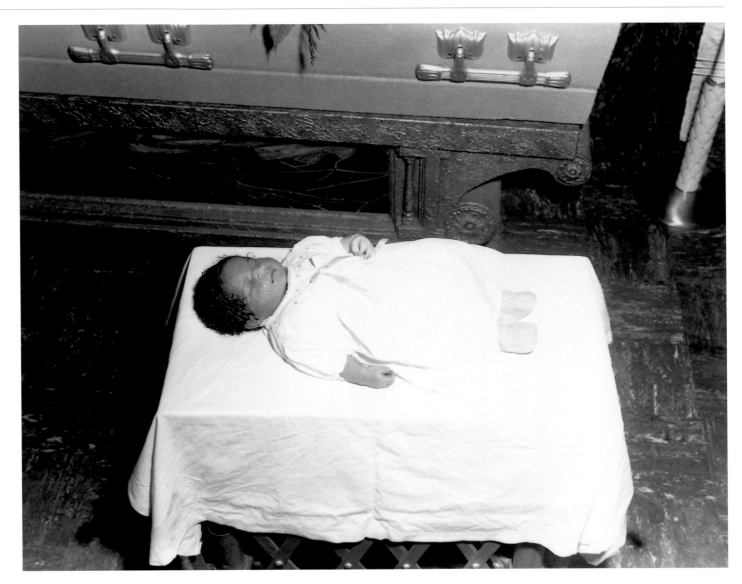

Infant funeral, Pine Bluff, 1950s.

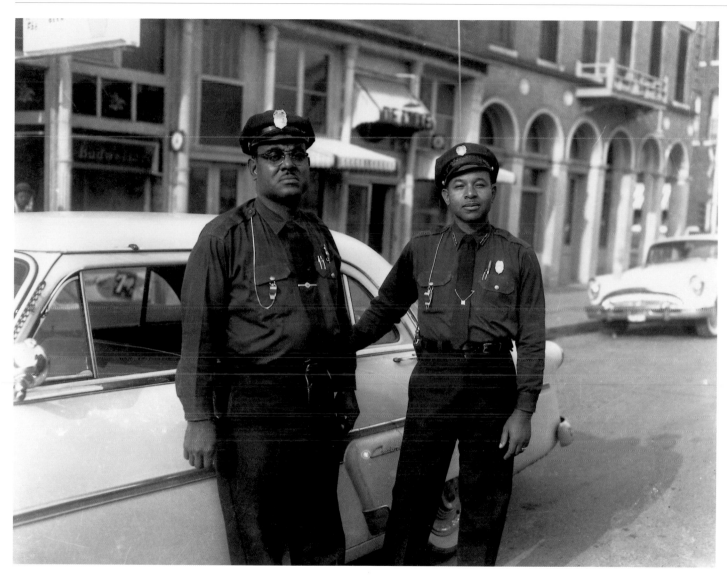

Patrolman Bradley, AM&N Security Chief Perkins, Pine Bluff, 1960s.

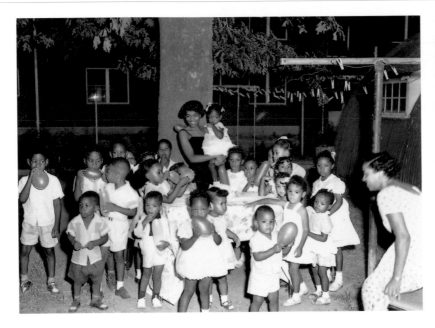

Birthday party, Pine Bluff, ca. 1956.

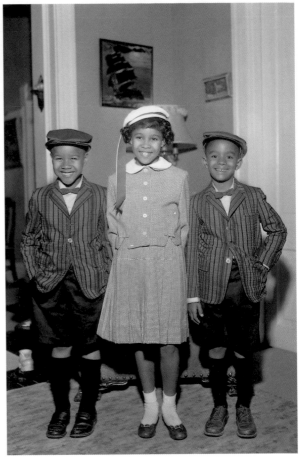

Children at Easter, Pine Bluff, ca. 1959.

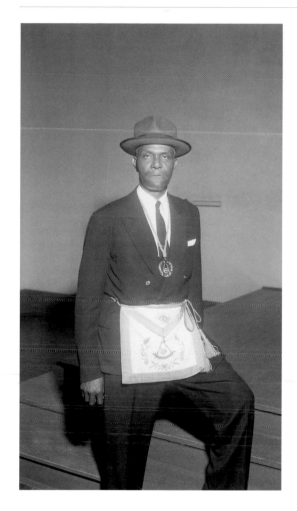

Man with Masonic Lodge apron, Pine Bluff, 1950s.

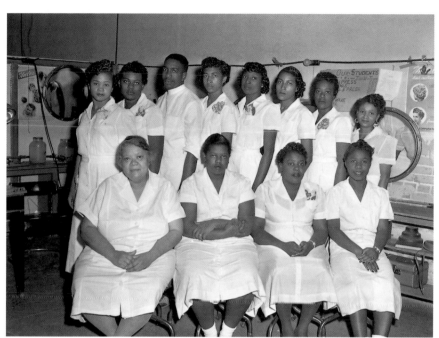

Beauty school class, Pine Bluff, 1950s.

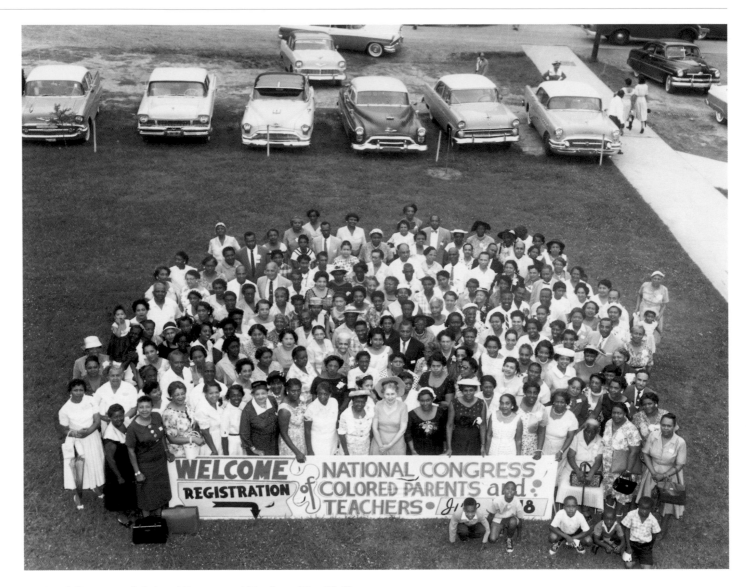

National Congress of Colored Parents and Teachers, Pine Bluff, 1958.

Miss Bronze Beauty Pageant,
Pine Bluff, ca. 1960.

Miss Bronze Beauty Pageant,
Pine Bluff, ca. 1960.

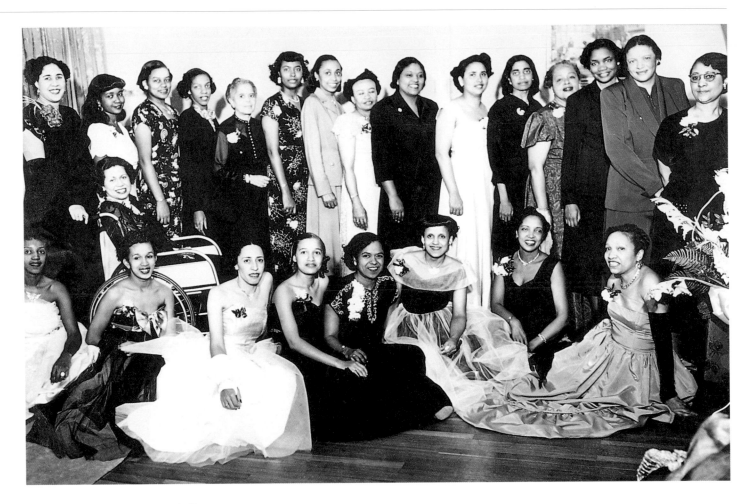

AKA luncheon group, Pine Bluff, 1950s.

Davy Crockett (Michael Grice)
and friend, Pine Bluff, ca. 1957.

Farm family, near Elaine, Arkansas, 1950s.

Nightclub scene, Pine Bluff.
Date unknown.

AM&N Choir concert
poster, Chicago, 1950s.

Harmonizers, Pine Bluff, 1950s.

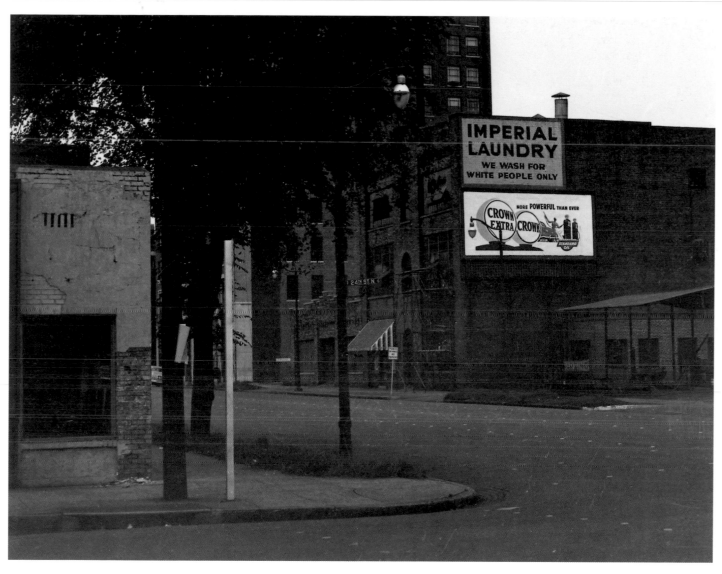

"We Wash For White People Only," near Birmingham, Alabama, 1950s.

Miss Correct Posture, Pine Bluff, 1968.

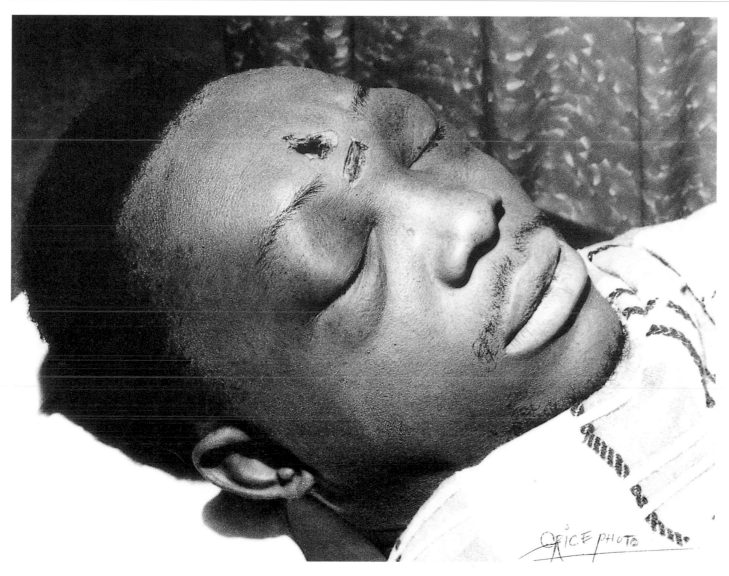

Cornell Russ, Pine Bluff. Date unknown.

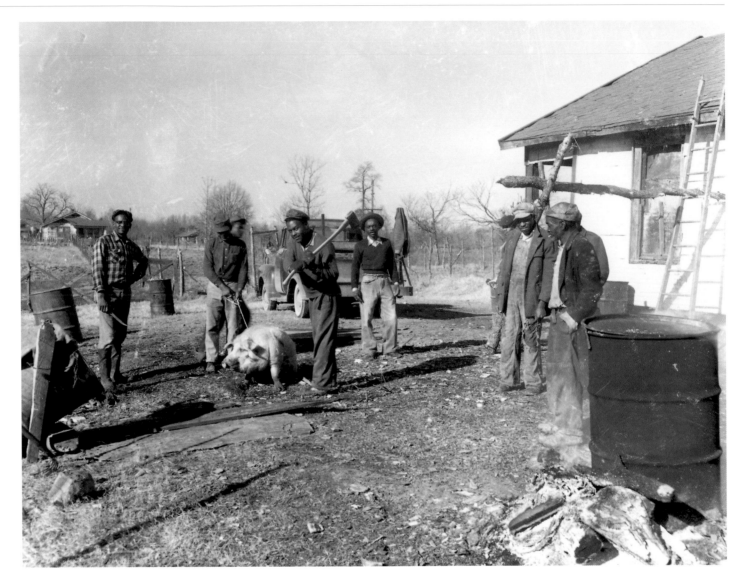

Hog killing, near Pine Bluff, 1950s.

Birthday party, Pine Bluff. Date unknown.

Michael Grice and Jean Bell Grice, Pine Bluff, ca. 1958.

Levi Flentroy funeral, Phoenix, Arkansas. Date unknown.

Checkers players, Pine Bluff, 1950s.

Christmas Pageant, Merrill High School, Pine Bluff, ca. 1958.

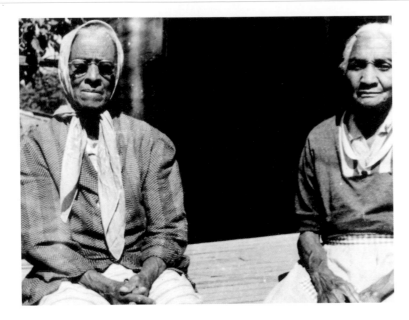

Two women, Sherrill, Arkansas, 1950s.

Rabbit's Foot Show worker,
Pine Bluff, 1950s.

High-school basketball
squad. Place unknown.
Date unknown.

Young football players,
Pine Bluff, 1960s.

Coach Foster and high-school basketball team, Pine Bluff, ca. 1960.

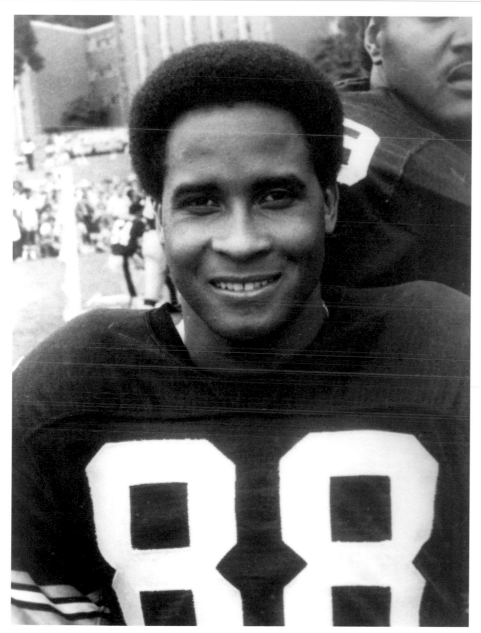

Lynn Swann, Latrobe,
Pennsylvania, 1970s.

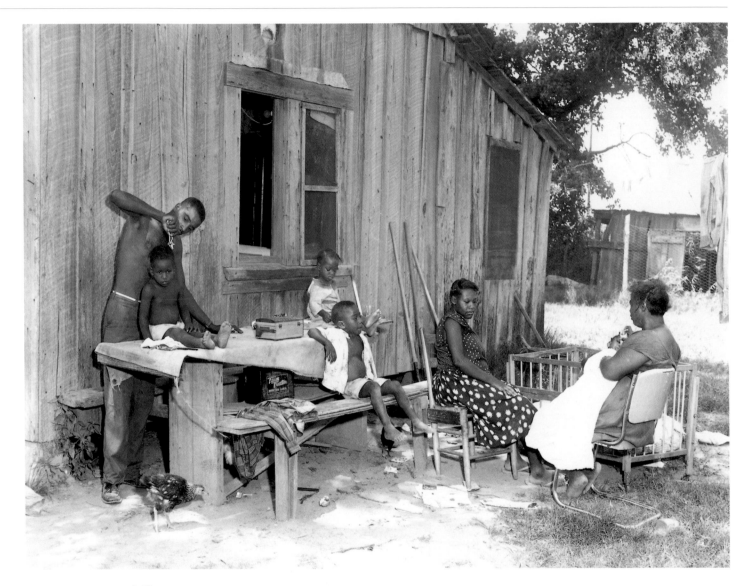

Haircut, near Pine Bluff, 1950s.

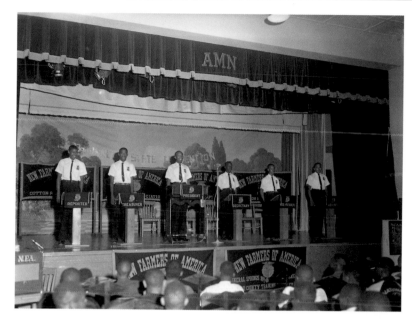

New Farmers of America,
Pine Bluff, 1960s.

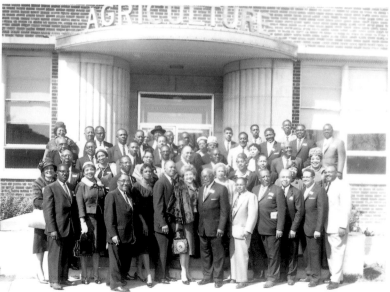

Agriculture faculty meeting,
Pine Bluff, 1960s.

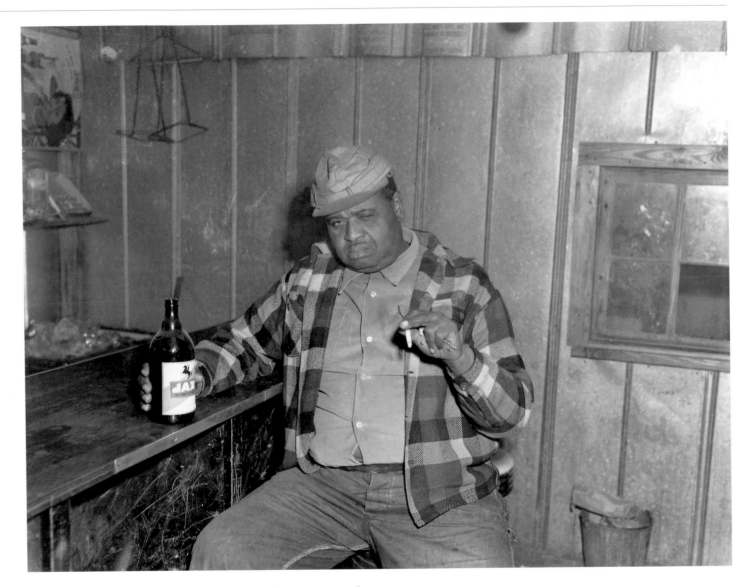

Man drinking Jax beer and smoking, Dumas, Arkansas. Date unknown.

Ray Thornton and Daisy Bates,
Pine Bluff, 1970s.

Harold Flowers and Margaret
Flowers, Pine Bluff, 1970s.

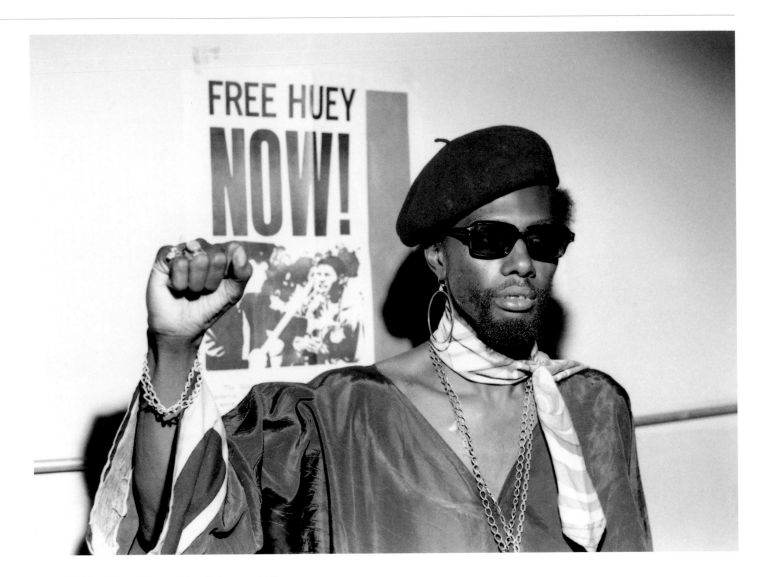

Sweet Willie Wine, Forrest City, Arkansas, 1960s.

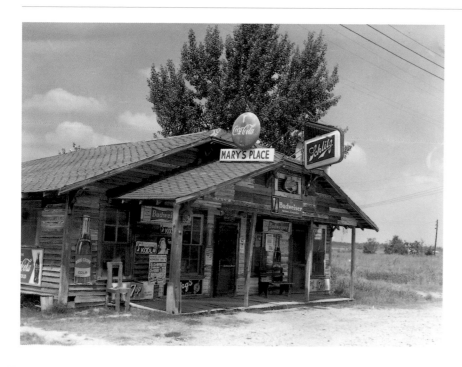

Mary's Place, near Humphrey,
Arkansas. Date unknown.

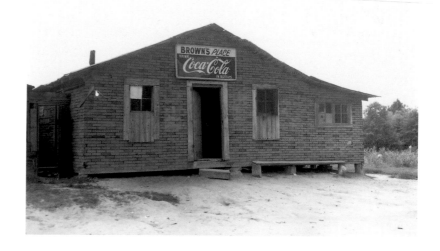

Brown's Place,
Pine Bluff, 1950s.

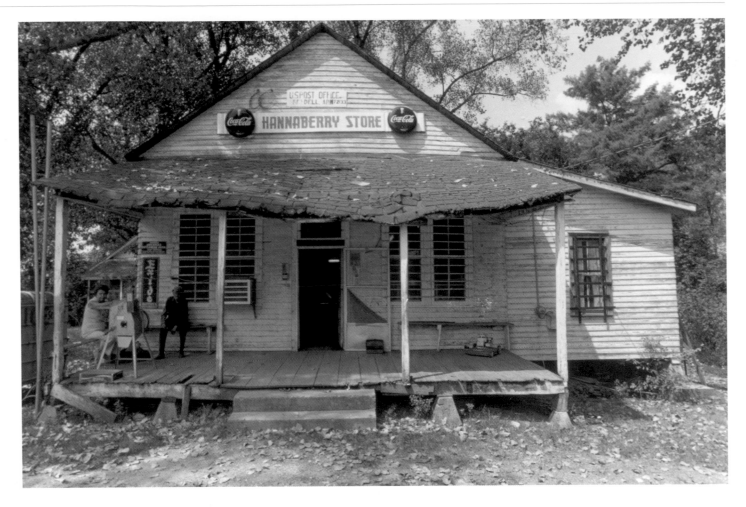

Hannaberry Store, Reydell, Arkansas. Date unknown. From color negative.

Fourth of July party,
Pine Bluff, ca. 1960.

Four seated men, Pine
Bluff. Date unknown.

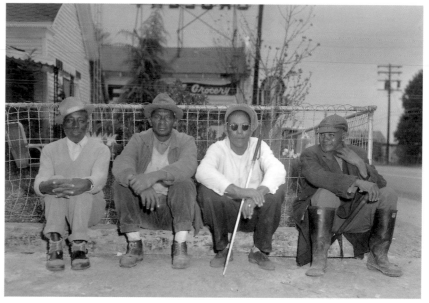

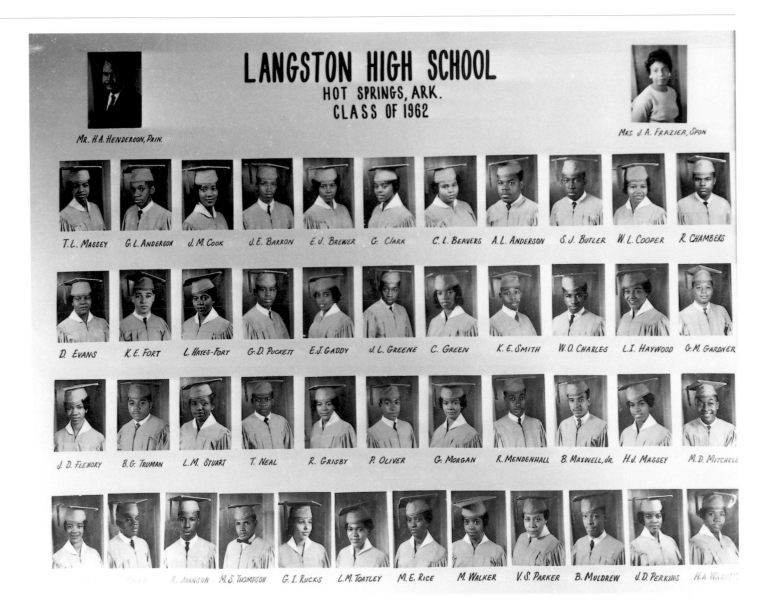

Langston High School, Hot Springs, Arkansas, 1962.

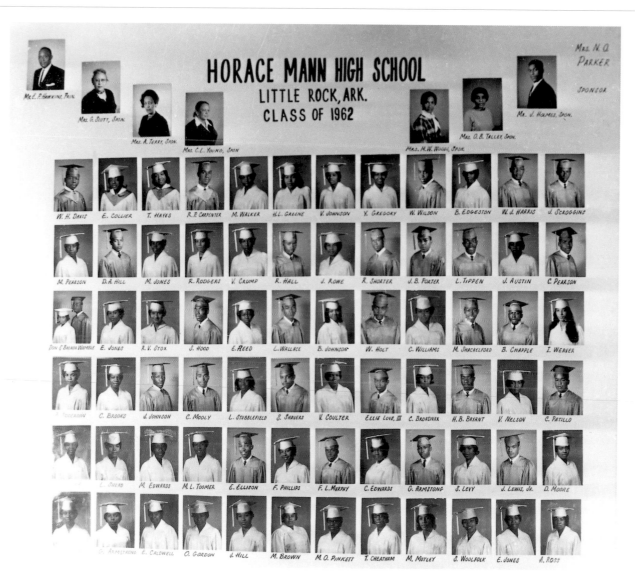

Horace Mann High School, Little Rock, 1962.

120

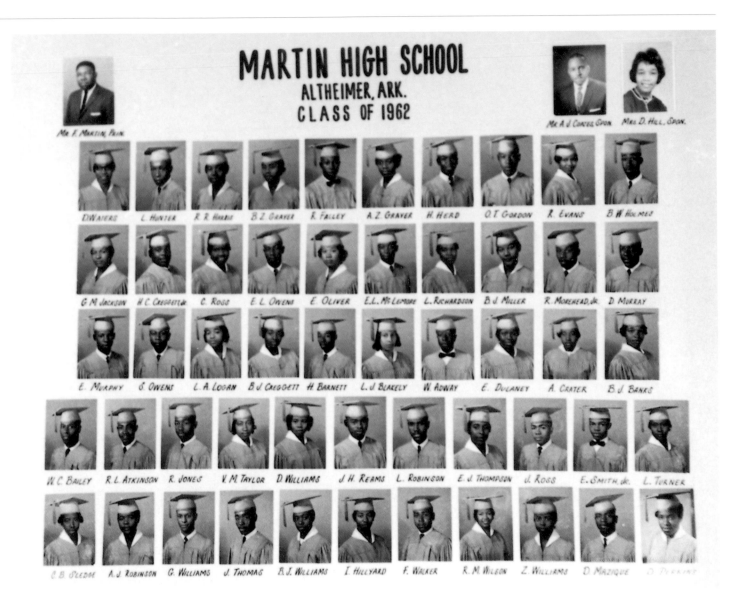

Martin High School, Altheimer, Arkansas, 1962.

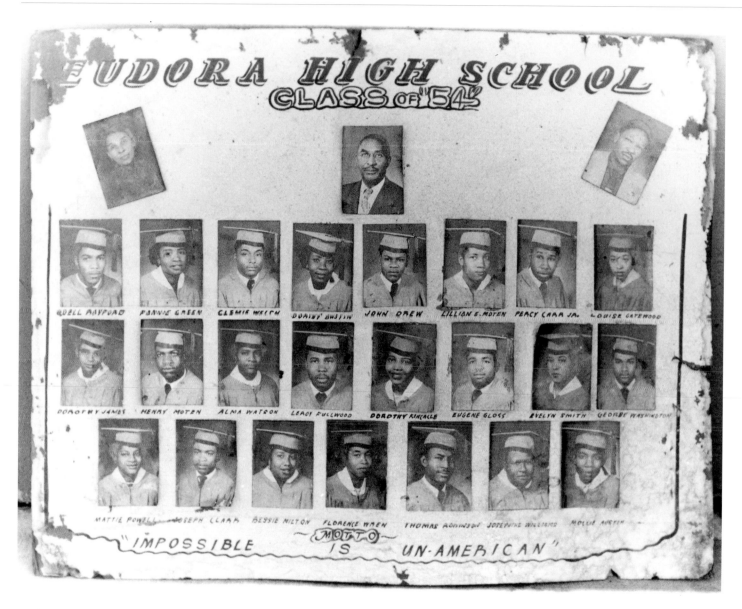

Eudora High School, Eudora, Arkansas, 1954.

Grice Studio sign, Pine Bluff, 1960s.

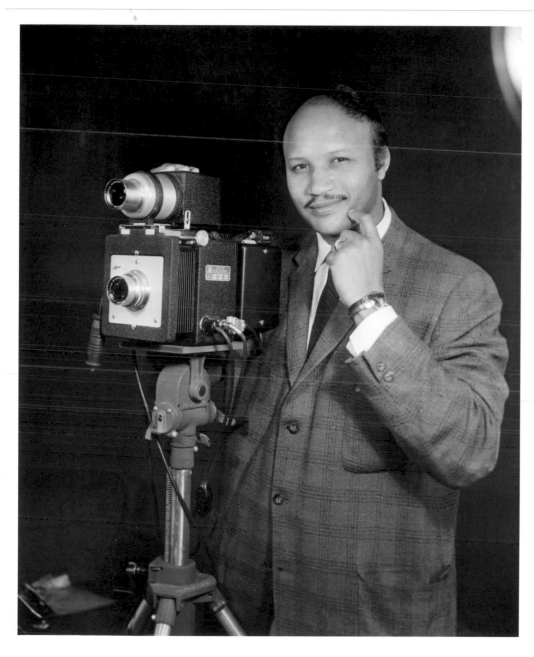

Self-portrait, Pine Bluff,
ca. 1970.

Tyrone Davis, Pine Bluff, 1970s. From color negative.

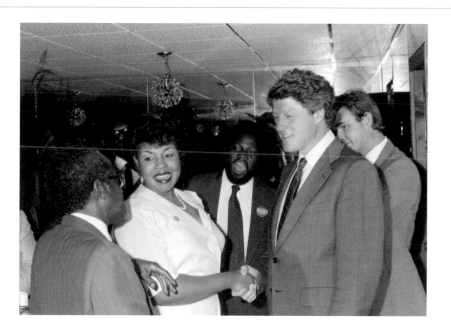

Bill Clinton, Pine Bluff. Date unknown.

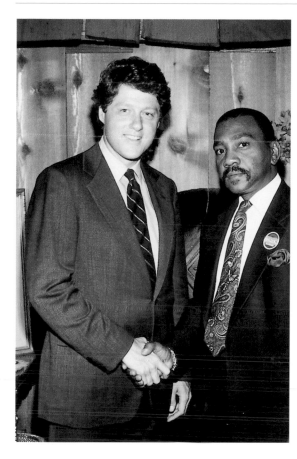

Bill Clinton and Perry Johnson, Pine Bluff, ca. 1980.
From color negative.

Basketball player Todd Day and Perry Johnson, Pine Bluff, 1980s. From color negative.

Basketball player Darrell Walker, Pine Bluff, 1970s. From color negative.

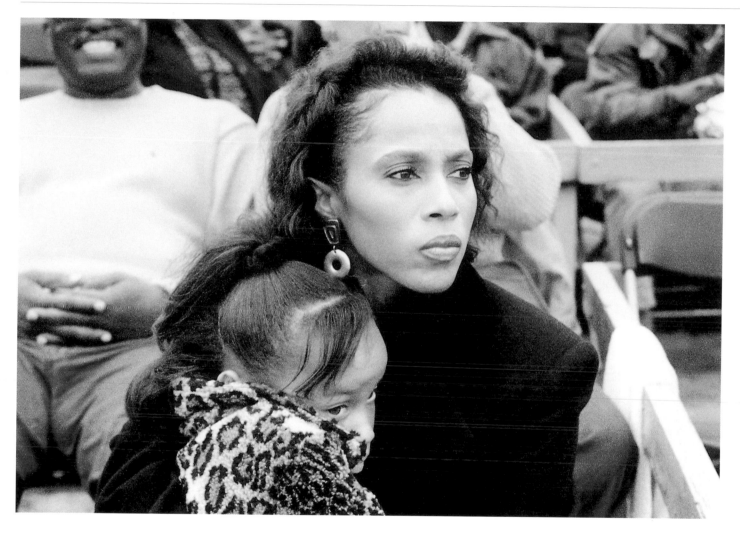

Mother and child at football game, Pine Bluff, ca. 1980. From color negative.

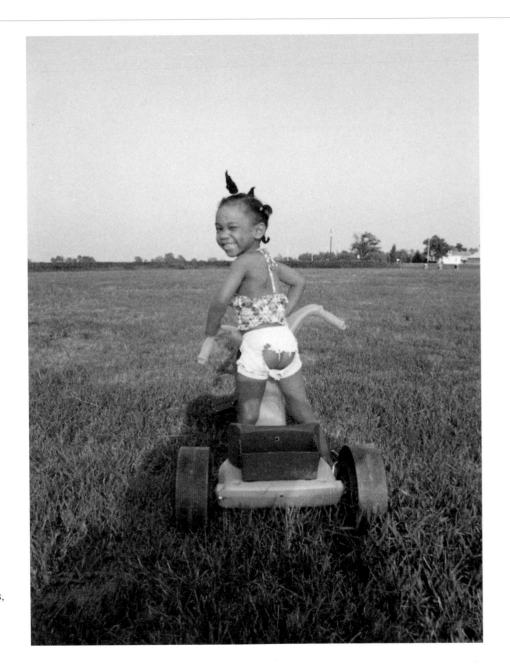

Rough rider, near St. Charles, Arkansas, 1970s. From color negative.

Dr. Charles Walker and Muhammad Ali, Pine Bluff, 1980s. From color negative.

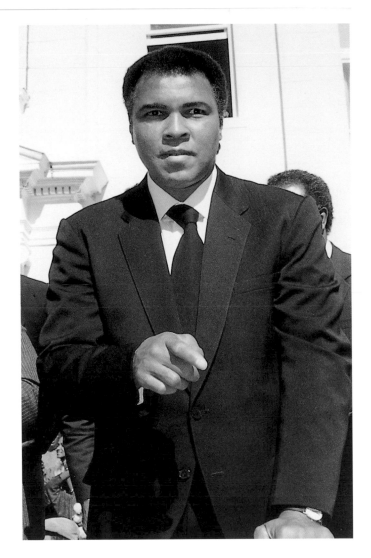

Muhammad Ali, Pine Bluff, 1980s.
From color negative.

Muhammad Ali, Pine Bluff, 1980s.
From color negative.

Razorback hearse, Pine Bluff, 1980s. From color negative.

Musician Johnny Taylor,
Pine Bluff, 1980s. From
color negative.

Girls with matching dresses and hair bows, Altheimer, Arkansas, 1980s. From color negative.

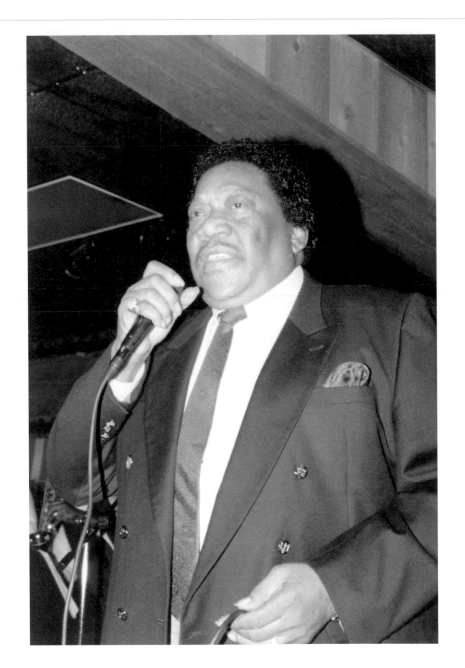

Musician Bobby Bland,
Pine Bluff, 1980s. From
color negative.

Carrots in love, Pine Bluff,
1980s. From color negative.

INDEX

139

INDEX